A Guide to the

Queen Charlotte Islands

A Guide to the
Queen Charlotte Islands

TWELFTH EDITION

Neil G. Carey

RAINCOAST BOOKS

Vancouver

First edition published in 1975

Twelfth edition published in 1998 by
Raincoast Books
8680 Cambie Street
Vancouver, B.C.
V6P 6M9
(604) 323-7100

1 2 3 4 5 6 7 8 9 10

CANADIAN CATALOGUING IN PUBLICATION DATA

Carey, Neil G.
A guide to the Queen Charlotte Islands

Includes bibliographical references and index.
1-55192-144-8

1. Queen Charlotte Islands (B.C.) – Guidebooks. I. Title.
FC3845.Q3A3 1998 917.11'12044 C97-910981-7
F1089.Q3C37 1998

Cover Photograph: David Nunuk

Printed and bound in Canada

To the Skidegate Reserve and Old Massett families who in 1955 with graciousness and dignity welcomed the four Careys as open-boat seafarers to share rest on their shores and food on their tables

Contents

Preface

During World War II and the Korean War, I was an officer in the United States Navy. After serving in Korea, I resigned my commission and, with my wife, Betty Lowman Carey, and sons, George and Gene, set out to explore the Queen Charlotte Islands – or Haida Gwaii (Islands of the People) – in *Thunderbird,* our six-metre (19-foot) Grand Banks dory. We followed the routes of the great Haida canoes that once ranged from the islands into Puget Sound.

Half a dozen years passed, but the Queen Charlotte Islands drew us back. Betty and Gene made a trip in Betty's four-metre (14-foot) dugout canoe along the west coast in 1962 and rediscovered the lagoon in which we would build our cabin. The next year Betty and I rounded the islands aboard a British Columbia Ministry of Forests vessel.

Meanwhile I had became a supervisor in the motion picture department of the Naval Missile Test Center at Point Mugu, California. In 1965 I resigned from that position to move to the Queen Charlottes. For 30 years we had a year-round home at Puffin Cove, a hidden lagoon on Moresby Island's rugged west coast, and a town home in Sandspit, on the east coast.

Throughout those years Betty and I explored, photographed and enjoyed the islands, taking *Skylark,* our eight-metre (26-foot) converted lifeboat, in and

out of every sound, inlet and bay. We have hiked along the drift of nearly every beach, followed many streams inland, climbed a few mountains, driven all the public roads and hundreds of kilometers of logging roads and studied the islands from helicopters and small planes.

I have worked in the woods as a logger, flown and hiked with prospectors, toured the mines, participated in the fishing industry on boat patrol, accompanied sport fishermen and taken North American, European and Asian scientists to various remote spots in the islands.

The Charlottes' rugged west coast has been explored by Betty in her precious dugout canoe, *BiJaBoJi*. She may have been the last person to enjoy the abandoned Haida villages and ancient campsites on lone dugout canoe journeys.

Betty and I have seen the islands' population grow from about 3,000 residents in 1955 to nearly 5,750 people in 1997. During the intervening years, mining towns and logging camps have come into being, served their purpose and been torn down or moved.

Within the past two decades the islands have been rediscovered. An ever-increasing number of tourists visit the islands – in May, June and July 1997 more than 14,300 people checked in at the visitor information centres in Sandspit and Queen Charlotte. Facilities at Sandspit Airport have been improved and expanded to accommodate those arriving or departing by air. The new and imposing $2,400,000 air terminal and visitor information centre, or the new and spacious centre in Queen Charlotte, are excellent places to commence your exploration and enjoyment of the Charlottes.

Others, wishing to enjoy a short time at sea or wanting to bring their vehicles, depart from Prince Rupert aboard one of the well-appointed ferries, *Queen of the North* or *Queen of Prince Rupert*. But whatever method you employ to arrive in the Queen Charlotte Islands, one thing is certain – you will never forget your visit. I hope this thoroughly revised and redesigned guide – now in its 12th edition – will provide you with everything you need to know about visiting the Charlottes and will inspire you to return to these marvelous islands time and time again.

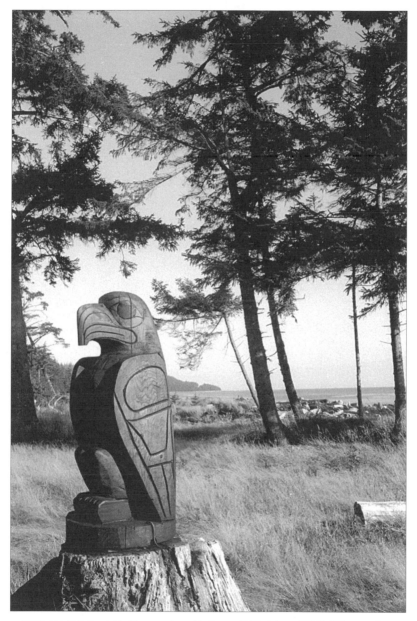

Eagle carving alongside the coast road between Skidegate and Tlell. Other carvings decorate this roadside.

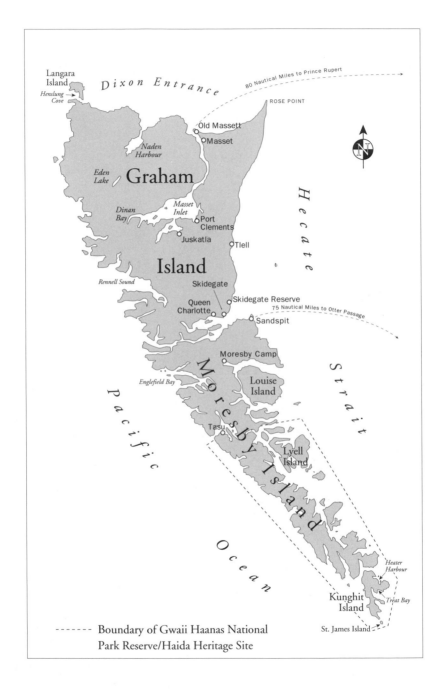

Langara
Island
Henslung
Cove

Dixon Entrance

80 Nautical Miles to Prince Rupert

ROSE POINT

Old Massett
Masset

*Naden
Harbour*

*Eden
Lake*

Graham

*H
e
c
a
t
e*

*Dinan
Bay*

*Masset
Inlet*

Port
Clements

Juskatla

Tlell

Island

Rennell Sound

Skidegate

Skidegate Reserve

Queen
Charlotte

75 Nautical Miles to Otter Passage

Sandspit

*S
t
r
a
i
t*

Moresby Camp

Englefield Bay

Louise
Island

*M
o
r
e
s
b
y I
s
l
a
n
d*

Tasu

Lyell
Island

*P
a
c
i
f
i
c*

*O
c
e
a
n*

Heater
Harbour

Kunghit
Island

Treat Bay

St. James Island

- - - - - - Boundary of Gwaii Haanas National
Park Reserve/Haida Heritage Site

1 Getting There and Around and About

To the sailor or fisherman plying the Inside Passage to Alaska, the Queen Charlotte Islands exist only as names on a chart, for this archipelago of some 150 islands and islets – arising as peaks of a submerged mountain chain – lies far out of sight of the regular lanes of travel. The islands are much like coastal British Columbia and Alaska, but in miniature. Here mountain peaks reach less than 1,220 metres (4,000 feet), and the fjordlike inlets are only eight kilometres (five miles) long rather than 10 times that.

The Charlottes, as they are called by nearly 5,800 residents, consist of six main islands – Langara, Graham, Moresby, Louise, Lyell and Kunghit – grouped in a rough triangular shape 250 kilometres (156 miles) long and 85 kilometres (52 miles) wide at the point of greatest width. Moderated by a northeast-moving current separating from the great *Kuroshio* (Japan Current) and a coastal countercurrent, the islands have an annual average temperature of 7.8° Celsius (46° Fahrenheit), with only 135 centimetres (53 inches) of rainfall on the east side of the mountains – despite slanderous rumours of continual downpours.

Although they lie between 52 and 54 degrees North Latitude – as do Goose Bay, Dublin, Amsterdam, Berlin and Magnitogorsk – the Charlottes have no

extremes of temperature and are peacefully removed from the crush of all but major world events. On the islands' northernmost point, the Langara Island lighthouse winks across the moving water of Dixon Entrance at Cape Muzon, Alaska, 45 kilometres (28 miles) distant. In spring, summer and fall these waters, rich with salmon, halibut and crab, are speckled with the boats of commercial and sport fishermen. The commercial fishermen deliver their catches at Masset or Prince Rupert, or to packer vessels that transport the fish to mainland canneries or freezing plants. Most of the devoted sport fishermen enjoying the Langara Island and Naden Harbour area fly to the fishing lodges – located ashore or afloat – in twin-engine floatplanes operating from Alliford Bay.

Archaeologists estimate that the Charlottes have been inhabited for more than 7,000 years. Petroglyphs, similar to those at Wrangell, are uncovered by the ebb tide on the southwest shore of Lina Island, near Queen Charlotte. Who were those ancient artists?

In 1774 the Haida paddled their great dugout canoes seaward to greet the first recorded European explorers. The Haida were soon renowned for their distinctive sculpture and lavish potlatches, and were famed as hunters of the sea otter whose rich fur was prized by traders sailing on to China.

The following decades were a time of vast cultural and social change for the Haida. They were decimated by the diseases, mainly smallpox, as well as the alcohol brought by Europeans. As settlers moved in, legal and social pressures caused further disintegration of traditional Haida culture, especially legislation in 1884 outlawing the potlatch. Most of the scattered Haida villages were abandoned before 1890. Today deer browse in these old seaside villages where decaying cedar logs rim longhouse excavations and a few leaning mortuary and totem poles are found amid encroaching second-growth trees. Now most Haida live on reserves at Skidegate and Old Massett on Graham Island. In the past five decades Haida culture has experienced renewal, especially in a vigorous revival of its highly developed and spectacular art.

Graham Island, the largest of the Charlottes, was the first to attract settlers. These pioneers came to the low, flat east coast and to the shores of Masset Inlet, located in the island's centre. Thin, acid soil, a short growing season and lack of adequate transportation to markets discouraged most of these farm-oriented people. Today Graham Island, with 12 villages, settlements and camps – most connected by good blacktopped road – is home for five out of every six

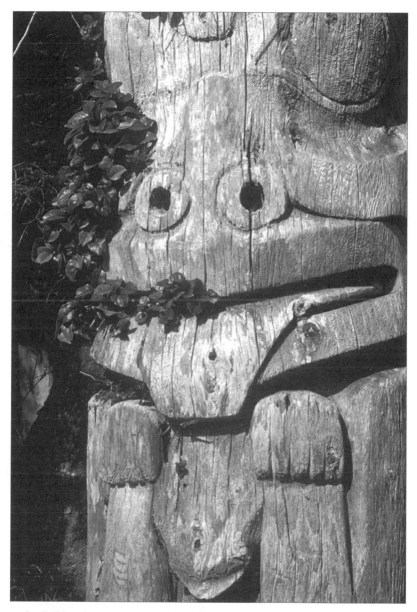

Symbolizing the Haida who were the first inhabitants of the Queen Charlottes, this weathered totem peers from the encroaching forest at Ninstints, an abandoned village in Anthony Island Provincial Park, also a world heritage site.

islanders. Outlying logging camps at Tartu Inlet, Eden Lake, Naden Harbour and Dinan and McClinton bays are served by boat, amphibian plane or helicopter. Employment is primarily in logging, fishing, government and services.

In the fall of 1980 an all-tides ferry dock was completed at Skidegate on Graham Island, and in mid-November the 101-metre (332-foot) *Queen of Prince Rupert* commenced scheduled runs between Prince Rupert and Skidegate, a distance of 93 nautical miles. This modern 18-knot ship – part of British Columbia's excellent ferry system – has a capacity of 80 vehicles and 504 passengers and, late May through September, makes six round-trips weekly, taking approximately six hours for each crossing. Storms may delay but rarely cancel a sailing. The ship has 84 staterooms, including one for the disabled.

A year-round schedule is maintained between Skidegate and Prince Rupert, and thence to Port Hardy. In summer – June through mid-October – these routes are served by the *Queen of Prince Rupert* and the larger *Queen of the North*. The latter ship is 125 metres long (410 feet), cruises at 22 knots and carries up to 157 cars and 800 passengers. This comfortable ship has 95 staterooms, with one able to accommodate wheelchairs.

In summer the trips between Prince Rupert and Port Hardy are 15-hour day cruises through the spectacular Inside Passage; north one day, south the next. On the winter schedule – mid-October through May – one ship, the *Queen of the North* or the *Queen of Prince Rupert,* takes both runs: three round-trips between Prince Rupert and Skidegate each week, and one between Prince Rupert and Port Hardy, with a stop at McLoughlin Bay (Bella Bella). As one crewman told me, "If it's legal on the road, the *Queens* can carry it."

Getting any place should be part of the fun, so try to include the "Totem Circle Route" in your plans. You can take the ferry operating between Tsawwassen – south of Vancouver – and Duke Point – just south of Nanaimo – on Vancouver Island. From there you drive north on scenic Highway 19 to the ferry terminal at Bear Cove, just south of Port Hardy, where you board the comfortable ferryliner for the 274-nautical-mile voyage to Prince Rupert, and thence on to the Charlottes.

After embarking at Port Hardy, pick up the key to your stateroom at the purser's office (if you want this extra comfort), then relax and enjoy your cruise through the spectacular Inside Passage. Thrill to the ever-changing scenes of the majestic, tree-covered Coast Mountains. Watch bald eagles effortlessly

soaring. Perhaps a pod of orcas (once called killer whales or blackfish) will be sighted systematically patrolling Johnston Strait, or one or two humpback whales may leap clear of the calm water. The mate on bridge watch usually announces such sightings and provides other interesting information. Pass isolated waterfront settlements, logging camps, lighthouses, commercial fishing vessels and barges piled high with great logs. Guess the destination of those powerful, slow-moving tugs and their heavy tows.

Passengers – except day cruisers – and all vehicles must disembark at Prince Rupert. Vehicles enter the ferries at bow or stern and leave by the opposite end at the next stop. Reboard the *Queen* crossing Hecate Strait to Skidegate, where you will begin days or weeks of exploring the fascinating Charlottes. Remember, however, that even though Hecate Strait is calm on most crossings, it can be rough. On a Monday in January 1997 Betty and I enjoyed a smooth six-hour trip to Prince Rupert. Thursday forenoon's scheduled departure was delayed until the following morning because Hecate Strait was too boisterous, and we didn't reach Skidegate until Friday afternoon. Similar delays may occur in the summer.

Friendly, helpful personnel make riding the *Queen of Prince Rupert* or the *Queen of the North* a pleasure. The cafeteria serves good meals at reasonable

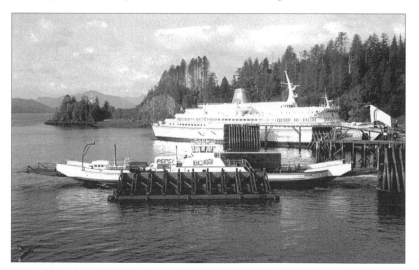

The *Kwuna* leaving its slip at Skidegate Terminal. The *Queen of the North* is in the background.

prices and is open for coffee and snacks during most of the trip. Comfortable staterooms or dayrooms are available. Ship-to-shore telephone, a bountifully stocked gift shop, an elevator from the car deck to the lounge and promenade decks and facilities for the disabled are some of the amenities of these fine vessels. Numerous large picture windows offer views of superb land- and seascapes, whether one is enjoying a hearty meal in the spacious dining room, relaxing or reading in a soft, adjustable chair inside or on deck or studying a chart and making plans in the well-stocked bar. On clear days land is within sight at all times.

The ferry is a pleasant and relatively economical means of travel to and from Prince Rupert or Port Hardy. Reservations are always recommended. (See the **Recreational Directory** for more details.)

Before heading home you could spend some time visiting the bustling seaport of Prince Rupert and the North Pacific Cannery Village Museum at Port Edward. This is British Columbia's oldest surviving salmon cannery and only 30 minutes from Prince Rupert. Then board an Alaska State Ferry and head north to the Last Frontier or drive there via Highways 16 and 37. Alternately you could drive east on the spectacular Yellowhead Highway 16 and enjoy miles of roadway pinched between towering snowcapped peaks, a busy railroad and the broad Skeena River. East of New Hazelton you might see Native people gaff-fishing salmon at the Bulkley River gorge in Moricetown. When you arrive at Prince George, continue east to Jasper National Park or turn south on Highway 97 and enjoy British Columbia's vast and varied interior. This is a region of rolling land, spectacular river valleys and ever-changing hillsides where ranching, logging, and mining are the prime sources of employment. You will see multicoloured grain, coal or lumber cars being pulled over railroad tracks that snake through the valleys just above swift-flowing rivers. A side trip to the historical and restored gold mining town of Barkerville may be in order before continuing on to 100 Mile House, Cache Creek and Vancouver. This is a year-round route over good asphalt highways.

But let's return to the Charlottes. After your ferry crosses Hecate Strait and enters the deep-water channel of Skidegate Inlet near Lawn Point, Graham Island is close abeam to starboard. Scattered homes or plumes of wood smoke are sighted among wind-tried trees. The beaches are wave-washed rock and coarse gravel, generously covered with greying drift logs. Coming into view on

the shore of open Rooney Bay and climbing gentle hillsides is the attractive and rapidly expanding Haida village of Skidegate. The band (community) office, built on the seaside in traditional longhouse design, is fronted with a tall totem pole designed by Bill Reid, world-renowned Haida artist.

Torrens and Jewell islands are observed before your memorable sea trip ends at the dock in Skidegate. Now you are ready to drive, hike or boat to new adventures in the Queen Charlotte Islands.

The *Kwuna*, a 72-metre (235-foot) ferry, was put into service in 1975 and runs between Alliford Bay, on Moresby Island, and Skidegate, on Graham Island. Based at Alliford Bay, the *Kwuna* has a capacity of 26 cars and 150 passengers and makes frequent scheduled crossings between 7:00 a.m. and 10:30 p.m. daily. Foot passengers can usually catch a ride into town.

The 20-minute trip affords a spectacular view of Skidegate Inlet, Bearskin Bay and a glimpse of Haina, the now overgrown site of an abandoned Haida village on the east end of Maude Island. Busy fishing boats, colourful pleasure craft and powerful oceangoing tugs with huge log barges are frequently seen and photographed in these protected waters.

From Alliford Bay a 14-kilometre (nine-mile) road curves along the south shore of Skidegate Inlet, crossing salmon streams and passing through stands

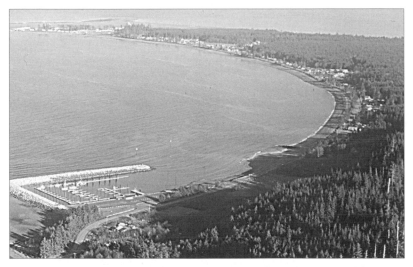

Sandspit – site of the principal Queen Charlottes airport *(upper left)*, visitor information centre, new boat harbour and the logging camp of TimberWest.

of second-growth spruce, hemlock, cedar and alder before reaching Sandspit on the low shores of Shingle Bay. Other visitors to the Charlottes arrive at Sandspit on daily flights from Vancouver. From a window seat your first glimpse of the islands may be the bent-thumb-shaped land beneath you, the site of the airport and the seaside settlement of Sandspit. This spit, between Hecate Strait and Shingle Bay, is the largest area of flat land on Moresby Island and home for nearly 500 people.

Approximately half of Sandspit's working population is involved in some phase of logging. Others work at the airport or in services. Local services include grocery, general, sporting goods and variety stores; a hotel and a growing number of bed-and-breakfasts; an RV park with sani-dump; gift shops, cafés and a service station; outboard sales and repair shops; vehicle and heavy equipment repair shops; vehicle rental agencies; sportfishing or sightseeing boat charters; a post office, a Royal Canadian Mounted Police office and the Sandspit visitor information centre (located within the air terminal and open during the tourist season); aviation fuelling facilities; a taxi; hunting and fishing outfitters; a golf course; and a retail liquor agency. Many people have retired here. Service clubs are Lions International, Rod and Gun Club, Alcoholics Anonymous and Narc-Anon.

Sandspit Airport, 6.4 metres (21 feet) above sea level, has a 1,560-metre (5,120-foot) runway. The air terminal has all facilities for travellers, including a coffee and snack bar, and there are daily flights between Sandspit and Vancouver utilizing either the 65-seat jet Fokker F28 or the 50-passenger Boeing Canada de Havilland Dash 8 aircraft. In addition, floatplanes make daily flights between Prince Rupert, Masset, Queen Charlotte and Sandspit (via Alliford Bay). Helicopters and vehicles may be rented at the airport; floatplanes at Alliford Bay. (For more information on transportation to and in the Queen Charlottes, see the **Recreational Directory**.)

A limousine service from Queen Charlotte meets the flights of Canadian Regional Airlines. Renting a vehicle, hiring a taxi, chartering a plane or helicopter or depending upon friends are at present the only means of getting to Old Massett or intermediate villages. If you choose to rent a vehicle, you may do so at the air terminal while waiting for your luggage to be unloaded, or you may pick one up in Queen Charlotte or Masset. The logging camps at Sewell Inlet and Beattie Anchorage (on Louise Island) are serviced by scheduled or

Hiking and beachcombing on the golden sands of Gilbert Bay, Kunghit Island.

charter flights from Alliford Bay, as are the settlements and logging and fishing camps on Graham and Langara islands.

At Rose Harbour, Kunghit Island, a few private homes have been built on the site of the old whaling station. Kayakers may elect to start or finish their trip here, coming or going by charter boat, amphibian plane or helicopter from Sandspit. Limited bed-and-breakfast facilities are available, as is sea transportation to and from Ninstints, Anthony Island.

Low, forested Kunghit Island was once used by the Haida for summer camps. There are lovely crescent beaches of golden sand at the head of open bays on the island's southeast and southwest sides – catchalls for interesting ocean drift. Rose Harbour, on the north, offers the seafarer mooring buoys and all-weather shelter.

Lonely Cape St. James on St. James Island lies at the southern tip of the Charlottes and is no longer a manned light and meteorological station. Today it is fully automated. In 1787 Captain George Dixon named both the island and the cape after rounding them in the *Queen Charlotte* on St. James's Day.

Cafés, hotels and motels are located in Masset, Port Clements, Queen Charlotte and Sandspit. Bed-and-breakfast accommodations are proliferating in all communities. Current information may be obtained from the visitor

information centres in Queen Charlotte or Sandspit.

For the vacationer or explorer who arrives in the Queen Charlotte Islands aboard his or her own vessel, or who brings a boat and outboard or a good kayak, a long list of recreational possibilities exist. Fuel capacity is normally the limiting factor – assuming you have time to wait out any storm. Marine fuels are currently available year-round only at Skidegate on Graham Island and, in summer, from a barge in Masset. (See Shops and Services/Marine Fuels in the **Recreational Directory**.) Rivulets along steep cliffs will keep your freshwater tank full. Just bring a garden hose and funnel. However, as the number of campers and hikers increases, so does the possibility of picking up the microbe *Giardia lamblia,* and contracting what is commonly called "beaver fever."

A sailor's best investment, after a seaworthy hull and reliable engine, are the dollars spent to acquire a set of charts covering the Queen Charlotte Islands, a copy of *Sailing Directions: British Columbia Coast (North Portion)* and a current copy of *Canadian Tide and Current Table, Volume 6: Barkley Sound and Discovery Passage to Dixon Entrance.* You will need the latter to keep informed of the 7.5-metre (25-foot) tidal range. It is also prudent to carry an extra anchor and plenty of line or chain. A line to the shore is sometimes necessary, and storms can make safe anchoring difficult. Furthermore, you might find a number of boats crowding each mooring buoy.

The islands' location, configuration and supply sources are such that if you cross Hecate Strait from Prince Rupert or Banks Island and land at Masset, it is convenient to cruise the Charlottes in a figure-eight course. Prevailing winds are from the northwest and southeast.

Whatever the mode of transportation, no one should try to fit an island vacation into a rigid schedule. Adverse weather can delay or cancel commercial flights and sailings for a day or so, and small planes and vessels may have to wait a few days for winds and seas to calm or fog to clear.

2 A Little Bit of Natural History

Hecate Strait, with an average width of 96 kilometres (60 miles), separates the Charlottes from coastal islands to the east. The southern half of Hecate Strait is generally deep; the northern portion, comparatively shallow. The Charlottes lie on the edge of the continental shelf, and only two or three kilometres (one or two miles) offshore the shelf plunges deep into the Pacific.

This is Canada's most active earthquake area. Many hillsides are scarred by slides, most initiated by seismic activity and/or heavy rainfall. Scientists read a long history of geological violence in local rocks, for the Queen Charlotte Islands were intruded, uplifted and folded until, looking like marble cake, they were broken open, then partially glaciated and eroded. The higher peaks are often bare of vegetation and snow-covered during most of the year. Slopes and cirques above the tree line are frequently decorated with emerald alpine meadows.

Columbian blacktail deer were introduced to the Charlottes well over a century ago as a ready meat supply. With abundant forage, a mild climate and no natural predators, they prospered and are found on all islands. These deer are not difficult to hunt, are smaller than their mainland cousins and provide delicious venison. (See Fishing and Hunting in the **Recreational Directory**.)

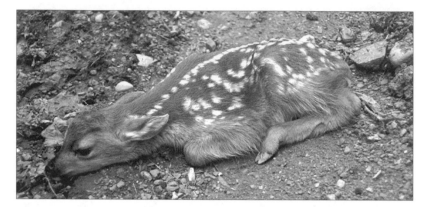

Although it might seem otherwise, this fawn is not hurt. It is merely "hiding" on the gravel road. Its mother is no doubt nearby. These lovely creatures are frequently seen in late spring or early summer.

Drivers may encounter these graceful animals day or night. I always enjoy the sight of a doe or fawn bounding along a tree-lined road, or an old buck – white rump flashing, belly swaying like a hammock – following my route until he disappears into a hidden roadside trail. Be warned, though, that day or night deer sometimes make what appear to be suicidal dashes in front of vehicles, a disaster to both.

During the late spring or early summer, you may discover a tiny spotted fawn lying still alongside – even on – the road, in the grass or on a secluded beach. It is not lost or abandoned, just hiding. Soon after you depart, its mother will return to feed and care for this cuddly creature that you may be tempted to "help" or claim as a pet, which is both illegal and potentially fatal to the fawn.

Other introduced animals – the elk, raccoon, squirrel, beaver, rat and muskrat – continue to expand their range each year, with the raccoon, squirrel and rat inhabiting many of the islands.

Populations of some ground-nesting birds have declined since raccoons were introduced during the 1930s. Norway rats on Langara and Lucy islands have so depleted the storm petrel, auklet, murrelet and puffin stocks that the Canadian Wildlife Service conducted a successful extermination program a few years ago.

Black bears are often seen on all major islands. Some attain greater size than most mainland blacks. If you sight a cub or two in a tree, it probably means

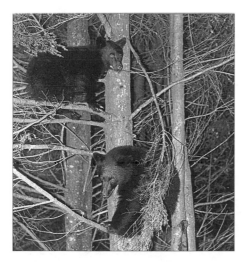

These black bear cubs scampered up a tree when signalled by their mother. As of late 1997 no one has been injured by a bear in the Charlottes. However, as tourism grows and hunting diminishes (or is prohibited), the chance of being attacked by a bear increases. Be cautious.

the mother has made them scamper and climb to safety and is not far away. Be wary and do not get between her and the cubs. Bears can move terrifyingly fast.

You may be lucky enough to see a sleek-furred river otter romping along a stream, tobogganing down a muddy slope or fishing in some sheltered bay. These thick-bodied, long-tailed animals are the subspecies *Lutra canadensis brevipilosus,* the Queen Charlotte otter. Unfortunately another indigenous animal, the dwarf, mouse-grey Dawson caribou, cannot be seen today. It became extinct more than a half century ago.

Several subspecies of birds and plants inhabit the Charlottes. Birdwatchers may encounter some difficulty in identifying birds on the islands, for many indigenous birds tend to be darker than their mainland counterparts. Subspecies of three birds, the saw-whet owl, the hairy woodpecker and the Steller's jay, are found only in these islands. A subspecies of the pine grosbeak is found here and on Vancouver Island, while a subspecies of the song sparrow makes its home here and on Alaskan islands. In addition, you will probably sight a few lazy or storm-battered migrants that have stayed to enjoy the islands' mild climate.

The Steller's jay was voted British Columbia's official bird in 1987. The peregrine falcon was a close second. Jays are often seen around bird feeders, heard chattering in scrub trees and rosebushes or glimpsed in the sheltering coniferous forest. This intelligent, friendly – if you supply food – bird, with

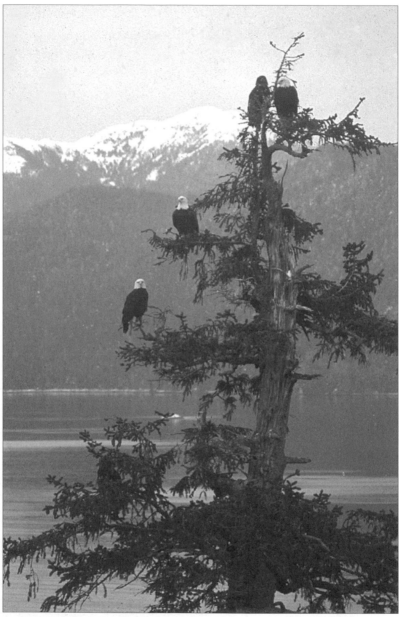

Adult and immature bald eagles perched high above Tasu Sound.

black foreparts, long crest and deep blue body, wings and tail, is a worthy addition to Canada's provincial birds.

No matter where you go on the Charlottes, you will see bald eagles. They enjoy riding the thermal updrafts and soaring about on windy days. It is especially thrilling to watch them from a helicopter or light plane as they appear to drift alongside or below. The magnificent adults are unmistakable: their white head and tail plumage contrasts sharply with the dark brown, nearly black body. Until their fourth or fifth year, immature birds are brown, mottled with white and are sometimes mistaken for golden eagles, a species not found in the Charlottes.

An isolated point, a tall grey snag or a high, windswept rock are locations preferred by eagles for their lookouts. During a short summer cruise along Moresby Island's sparkling east coast, Betty and I quit counting after recording 100 eagles – many of them immature – strutting along the tide line or perched to observe the shore where food may be washed up.

Boaters commonly see eagles cruising a kilometre or so from shore. With an abrupt swoop the great eagle's talons may dip into the sea and the bird rises with a small fish. After gaining height, the eagle may float on outspread wings, then swing its feet forward while bending to take another fish and eat it on the fly.

In late summer and early fall eagles flock to streams where salmon are spawning, intent on gorging themselves on the helpless spawned-out fish. At any time of year – including in the settlements – you can hear the eagle's high-pitched squeaks and rapid, sharp chirps, or see them soaring on wings that span over two metres (seven feet). Their nests, usually in large trees away from civilization, often look like misplaced piles of brush.

Indigenous plants found in the islands include six mosses and liverworts that exist only in the Charlottes; in addition, there are other plants known only here and in Japan or in Western Europe.

The waters surrounding the Charlottes abound with life and activity. Commercial fishing season begins when seiners and gillnetters congregate during March and April to compete with sea lions, seals, porpoises and great flocks of seabirds for the millions of roe-filled herring. Halibuters, salmon trollers and seiners work around the islands until late September or mid-October when the season closes – after the streams have been filled to capacity with spawning salmon. Hardy fishermen using hundreds of traps to catch Alaska

black cod (sablefish) labour offshore nearly year-round. For the sportsman there are still a few late-arriving salmon, returning steelhead and the always-present trout and Dolly Varden.

Whale watching is popular in late spring and early summer when a few grey whales, migrating from the warm lagoons of Baja California to the chill waters of the Bering Sea and Arctic Ocean, pause to feed in Skidegate Inlet. As the grey whale population expands, so do the numbers seen here. More than 26 were counted in the inlet one year between April and late June. They may be sighted singly or in small pods, bottom-feeding on amphipods in the shallow water.

Scan the inlet for the blow – water or condensing vapour – rising as high as 3.6 metres (12 feet) when the whale exhales. Once sighted, you will likely see it again; or nearby, a smaller blow, evidence of a cow and calf. They may make short dives and frequent blows, stirring up mud in the shoals, or they may stay down for several minutes. Orcas, six to nine metres (20 to 30 feet) in length, are sometimes seen from the *Kwuna* or small craft operating in the inlets, or from along the coast. Travelling in pairs or pods of dozens, these large members of the porpoise family are easily identified by their glossy black back, white underside and dorsal fin up to two metres (7 feet) in height for males. Less frequently sighted are humpback, sperm and sei whales.

During some summers, rafts of velella or "By-the-Wind Sailors," a sail jelly-fish up to 10 centimetres (four inches) long, move over the sea as an undulating mass of turquoise blue that numbers in the hundreds of thousands. When washed ashore and dead, they look like snow, are slippery as ice and stink!

In mid-summer yachtsmen or kayakers may be startled by sighting what appears to be an uncharted reef in a quiet bay or inlet. Your "reef" may be only a dense collection of moon jellyfish, each about 15 centimetres (six inches) in diameter, drifting within a metre of the surface.

Sea blubber, large jellyfish up to 50 centimetres (20 inches) in diameter, are often seen in the open ocean or roaming with the tide in bays and inlets. Their tentacles are often longer than three metres (nearly 10 feet) and may cause a stinging rash. They remind me of monstrous raw eggs.

Mushroom pickers and buyers begin flocking to the Charlottes in mid-August to harvest the valuable fungi. Most camp along the streams or lakes in logged-off areas and remain until late October.

3 Hunting and Fishing

You can hunt one or more species of game animals nearly year-round in the Queen Charlottes. Big game includes black bear, blacktail deer and elk, while small game in the form of raccoons can also be found. Game birds, such as blue grouse, and waterfowl, such as ducks, geese, coots and common snipe, also abound.

Deer hunting is excellent throughout the islands, although most blacktail deer are smaller than their mainland cousins and trophy animals are difficult to find. There is little gamy flavour in this tender and delicious venison. Black bear hunting is unexcelled, and there is a good chance of taking a mature animal with a head of record proportions. Only a few elk are taken each year. Elk are a challenge to a hunter's skill and patience. One young islander proudly told me how he shot a fine bull elk at the season's opening – and about the many tiring trips to pack out the meat and antlered head.

Blue grouse hunting is fair, varying from year to year. Waterfowl hunting is superior throughout the island's many bays, inlets and grassy flats. There is no open season for black brant.

Fishing is the most popular sport on the islands, perhaps because it is done amid delightfully tranquil and beautiful surroundings. In the Charlottes fishing

is a year-round sport, combining the best of freshwater and saltwater angling with an opportunity to land a big one if you are going after chinook (spring/king) and coho (silver) salmon or steelhead.

In the past logging sometimes took place to the water's edge. Now a green belt is left along the streams and beaches. Birds nest in the green belt, deer browse and trees cool the streams while helping to control the occasional superabundance of fresh water.

The gradient of many of the Charlottes' fishing streams is so slight that at high tide the streams may be full for nearly a kilometre inland from their mouths. At streams where the hook regulations and the number and type of fish permitted to catch vary, the angler will find the tidal boundaries posted.

The author returns to Puffin Cove with a lingcod and a red snapper. Although these are not considered game fish, they are good eating.

What's your pleasure? Will it be an unforgettable contest with eight kilograms (18 pounds) of fighting coho, or the pleasant, though less spectacular catching of a string of cutthroat, rainbow trout and Dolly Varden to cook over the campfire? Or will you opt for the excitement of tangling with an 11-kilogram (25-pound) steelhead? Or will you choose instead to spend a quiet morning in a small boat jigging for lingcod, red snapper, rockfish or halibut – perhaps a halibut so large it can't be safely boated? All of these possibilities exist in the Queen Charlottes and, with the exception of halibut fishing (closed January 1 to January 31), can be enjoyed at any time of year (if the salmon or steelhead have returned).

Chinook salmon enter Hecate Strait in March and are soon being caught in Skidegate Inlet. They are taking lures or bait herring in Tasu Sound – on Moresby Island's west coast – by early May. Occasionally a deep-trolling coho fisherman will land a chinook in Skidegate Inlet as late as mid-October.

In season a number of comfortable sportfishing charter vessels and lodges operate in the Charlottes. Chinook salmon begin showing up in numbers around Langara Island by April. Eager sport fishermen, ready for a reel burning battle, arrive in May and continue to enjoy excellent fishing until mid-September. Some boats follow the salmon down the west coast of Graham Island during the summer and finish the season fishing coho in or around Moresby Island's Cumshewa Inlet during August or September. Small boats, motors, fishing tackle, rain clothes (when needed), life jackets or floater suits, catch-care for those 13- to 27-kilogram (30- to 60-pound) chinooks, accommodations and airfare from Vancouver are included in the package price.

Coho usually appear by early June, increasing in size and number while they feed and slowly migrate to the streams of their origin. By late September or mid-October these mature salmon are ready to spawn, and coho fishing in the Charlottes is at its height. The precise time when coho school up off the mouths of streams varies, sometimes resulting in great fishing in one area and poor sport only a few kilometres away. Anyone fishing from late August to mid-October has a good chance to catch the limit. (Be sure to check local fishing regulations for current information concerning licences, limits and bait or hooks permitted.)

In tidal waters pink salmon frequently take a lure or fly, sockeye salmon occasionally and chum salmon rarely. It is illegal to keep pink, sockeye or chum

salmon caught in nontidal waters. Pinks, while not as large or such fierce fighters as coho or chinook salmon, do add variety to the sport and are great for smoking, an art the Haida have perfected.

November through April is when the wily, fighting steelhead trout flourish in many of the Charlottes' streams, providing a genuine challenge for the experienced fisherman, whether fly casting or drift fishing. A steelhead is an anadromous rainbow trout that has spent from two to three years in salt water growing large, independent and combative before returning to its native stream to spawn. Unlike all Pacific salmon, a steelhead does not necessarily die after spawning; from one to 35 percent of B.C. steelhead runs are repeat spawners.

Cutthroat, rainbow trout and Dolly Varden are taken year-round. These fish always put up a good fight for their size and are especially delicious when cooked with bacon over an open campfire.

Those who have fished salmon, steelhead and trout know what combination of rod, reel, line, lures and action is most successful for them. Those who haven't should be aware that this kind of fishing is something like training a dog: you have to be wiser and have more tricks than your pet.

Rods most often seen along the streams, shores or in boats are 1.8 to 2.7 metres (six to nine feet) long, strong, of medium flexibility and mounted with noncorrosive guides and fittings. Spinning reels are the most popular and are usually loaded with 2.7- to 7.2-kilogram (six- to 16-pound) test monofilament line. Occasionally an angler will test his or her skill with a lighter line and more limber rod. Those who don't want to chance losing a precious salmon, especially during the coho derby, will use nine-kilogram (20-pound) test. Just keep the hook needle-sharp and untarnished.

In addition to flashers and spinners, leaders, swivels, weights and spare hooks, you will need a selection of lures, including a couple sizes each of Krocodiles, Kit-a-mat, Mepps Aglia, Comet, Black Fury, Dardevles, Buzz-Bombs, teaspoons, colourful bucktails and dry and wet flies. If I could have only one lure for trolling and casting, it would be a 10-centimetre (four-inch) Buzz-Bomb. As one of my more successful salmon-catching friends once advised, "Also buy anything else that looks pretty."

There is no guarantee that anything will work. I have been with ardent, experienced fishermen who flogged the streams and salt water all day without so much as a strike. Worse, we could see hundreds of 4.5- to 7.2-kilogram (10-

to 16-pound) coho darting about in the shallow water and two or three jumping near us at any time. On other days, the ones best remembered, a coho will strike on the first cast and not be seen until it rockets into the air attempting to shake the hook – and then the fight is on!

Those with larger boats may enjoy trolling in Hecate Strait from Skincuttle Inlet to north of the Tlell River, or in Dixon Entrance from Masset Harbour to the waters west of Langara Island, or through Skidegate Channel into Cartwright Sound, especially near Tcenakun (locally called Skidegate) Point. On reasonably calm days many people fish along the sharp drop-off of the extensive spit from Sandspit northward to the buoys marking the Skidegate

Sandspit resident Tina Bond with coho caught from the beach in front of her home.

shipping channel. Fishing is best when the tide is running, preferably during the flood tide when small fish are swept over the bar and salmon leap and splash in a feeding frenzy.

If the salmon don't cooperate, use a hand jig for lingcod, red snapper and halibut while working over the bottom of Cartwright and Virago sounds, Parry Passage or the ship channel near the entrance buoys to Skidegate Inlet. Fishermen in skiffs and small boats may feel more comfortable in the protected waters of the inlets and bays on the east coast of Moresby Island, in Skidegate Inlet, Skidegate Channel or near the entrance to Masset Harbour.

Try a half-kilogram (16-ounce) weight about 1.2 to 1.8 metres (four to six feet) ahead of a flasher trailing a hootchy-kootchy lure on a 60- to 75-centimetre (24- to 30-inch) leader. Packaged frozen herring is available in most sport shops, so you might use a lighter weight and tie on a headless herring impaled on tandem hooks, either 1/0 or 2/0. One hook is usually placed sideways near the tail and the other shoved upward through the herring's backbone. A slow-rolling herring is hard for any voracious chinook to ignore. If the tide is running, you may be able to just drift and work this bait. Keep that dip net or gaff within easy reach.

Nearer the mouths of streams or in small bays you may elect to cast, either from shore or boat. Almost all metal lures of assorted shapes and colours have their advocates. The one thing most favourites have in common is a touch of red someplace. There are days when a Kit-a-mat is the hottest lure; other times it will be a dressed Mepps Aglia #3 or a Krocodile. During two seasons I fished with a party that had enjoyed the sport in many of the world's most productive rivers and lakes. One member used only a Dardevle. She didn't waste time digging through her tackle box or changing lures. She just fished. At the end of each trip she had caught as many salmon or trout as anyone in the party, and her 8.4-kilogram (19-pound) coho – caught casting – tied for largest fish. The other big one was caught while slowly trolling a 57-gram (two-ounce) weight ahead of a green-and-white bucktail.

Waders and a sturdy dip net or gaff should be included in your gear, although I've seen a few 5.4- to 8.1-kilogram (12- to 18-pound) cohos caught by fishermen wearing street shoes while standing on rocks near back eddies. These fisherman skillfully fight their fish to exhaustion before slipping a finger inside the gill cover and proudly carrying the prize up the beach. A few years ago a

student hooked a 14.4-kilogram (32-pound) chinook while fishing from the plane ramp at Queen Charlotte. With a deft assist from his foot the prize fish was moved ashore.

September, when the greatest number of anglers are in the Charlottes and hotel reservations and boat and vehicle rentals the tightest, can be a month of cloudless days that prompt the fishing enthusiast to sport sunglasses and rolled-up sleeves. These are days when mallards and assorted ducks dabble and dive nearby, bald eagles float on thermals and the eager-to-spawn salmon lie offshore in cool tidal water, waiting for rain to raise the streams sufficiently for them to enter. When the rain does come, the fish charge upstream, some striking any bright lure cast within their sight. However, this can be a time of frustration and disappointment for the angler without a boat to get offshore, or for the fisherman who can't wait for the salmon to make their dash.

September can also be a month when one wild, rain-pelting southeaster follows another with only a few hours of letup in between. At such times soggy anglers cast or troll in dark, choppy waters fouled with drifting twigs, leaves and grass. These hardy individuals will be rewarded by the slamming strike of a heavy coho ripping off yards of monofilament before somersaulting into the air, crashing into the water and commencing a long, rod-bending run. Yes, the ducks are still there, getting ready for their migration, but the eagles are now perched on upper limbs of trees, watching for their next meal to swim or drift by.

Usually September is a month of mixed weather. There is enough rain to fill the streams and allow the salmon to go into the shallows on flood tides, then drift seaward with the ebbs until they are ready to make their purposeful swim to the gravel spawning beds. Those are the days you should catch your limit, whether fishing from the beach or a boat.

Salmon runs in some of the Charlottes' streams have been enhanced by private and government efforts. The first returns came to one of those streams in 1987. Hundreds, possibly thousands, of mature coho salmon worked their way along the shores of Shingle Bay to their home stream, finning, leaping and attracting eager fishermen.

Local and visiting fishermen enjoyed superb sport for many days, especially during the two hours before and two hours after high tide. Anglers in chest waders stayed dry as they followed the run across the gently sloping tide flats parallel to Sandspit's Beach Road. On two successive days I saw a young man

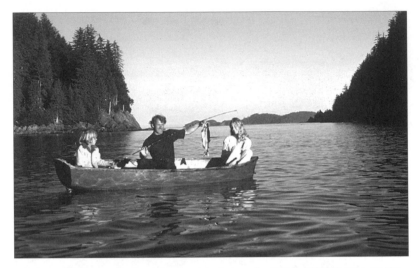

A pleased fisherman displays what he plans to have for dinner. Although coho are the favourite catch of salmon fishermen, pink salmon *(shown)* also provide good sport and excellent eating.

on his lunch break wade in up to his chest, cast a bright spoon and soon tie into – and land – a lively 4.5- or 5.4-kilogram (10- or 12-pound) coho. Not many places you could do that!

On a bright, calm September day, two of us in a Boston whaler dashed out to Skidegate Channel. As we came out of the narrows we saw salmon leaping near the mouth of Government Creek. The tide was nearly high and hundreds of excited pink salmon sprinted over the gravel shoals. Coho often swim quietly amid such confusion, so we fished there.

After a few casts with a dressed Mepps Aglia #2, I was fighting a scrappy pink. Minutes later I brought the exhausted fish aboard. Bill, my experienced companion, was soon playing his first pink salmon and greatly enjoying it. Within a half hour we landed three more of these tasty 2.7-kilogram (six-pound) fish. Too soon the tide turned and thousands of pinks started out of the stream in splashing schools. Hundreds at a time churned the water into riffles, as if it were flowing over a bouldered bottom. We sat in the boat, then stood ashore, our fishing rods ignored, watching as a dozen waves of salmon sought the deeper salt water. Memories of that rare spectacle will remain long after the thrill of the catch is forgotten.

If you have never seen salmon spawning, it is a sight worth the loss of a few hours' angling. Follow a stream inland and watch the pinks, which spawn before the cohos. Propelled by battered fins and tail, their backs often out of the water, they skitter and flop across rocky shoals before seeking rest in a quiet pool. Strength renewed, they respond to the primordial demand to propagate and move onward, perhaps leaping over an obstructing tree trunk where water swirls and churns until they reach a place where clear, cool water runs over fine gravel. With swift, violent movements of her skinned tail, the female excavates a small hollow area. Her hook-nosed, humpbacked mate hovers nearby, belligerent, ready to fight off other males. Satisfied, the female settles over the shallow hole and deposits her dark pink eggs. Quickly the male moves in and covers the eggs with fertilizing milt. Both scatter gravel over the redd (the nest), hiding the precious eggs that would attract hungry trout and voracious Dolly Varden, or be washed downstream to waiting gulls.

Exhausted, spawned out, the pair drift away to die. The next hard rain may flood the valley. In a day or so, when the stream recedes to its banks, the grassy floor of the forest will be littered with dead salmon: a feast for eagles, gulls, ravens, crows and gluttonous black bears fattening up for the winter.

October is often a month of heavy rainfall and violent winds. Streams rise overnight, their waters swift and turbulent. Determined salmon drive upstream. At these times some fishermen quickly land their limits; others fly home disappointed.

The winter run of steelhead enters the streams by early November – late-spawning coho are also here – to spend months teasing stalwart fishermen before spawning, then dying or slowly drifting back to the ocean. By May the steelhead are just memories – the kind that wondrous fish stories are spun from.

Between May and October there is a small summer run of steelhead in one or more of the short streams gushing into Tasu Sound, and it is possible that others exist, since some of the less accessible west coast streams have not had more than a cursory prospecting. None of the Charlottes' streams are more than a few miles long. Among the favourites on Graham Island are Datlamen, Honna, Mamin, Tlell and Yakoun. Moresby Island's main streams are Copper, Deena and Pallant. All of these streams are accessible by road and have holding pools where fish rest, feed and perhaps strike lures on their passage upstream.

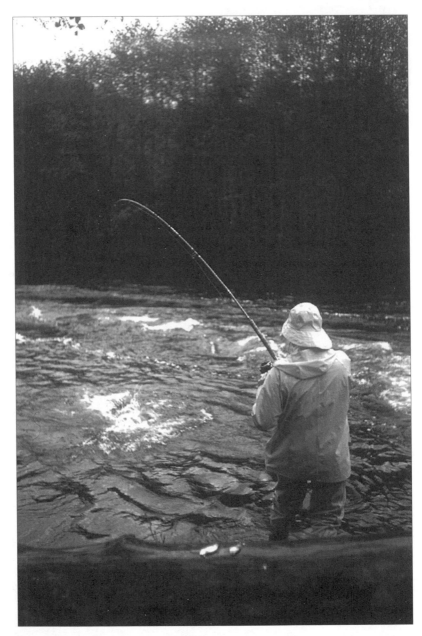

October salmon fishing in the Deena River.

In 1990 the Classified Waters System was implemented for 42 of British Columbia's most productive trout streams; eight of these are in the Charlottes and are named in the previous paragraph. In addition to other licences or stamps, a Classified Waters Licence must be purchased to fish these streams from September 1 to April 30.

Many of the local steelhead are high-jumping, slashing runners weighing 3.1 to 6.3 kilograms (seven to 14 pounds). The larger ones, up to 11.2 kilograms (25 pounds), are sometimes compared to big chinook salmon, and the fight a steelhead gives you may well last nearly a half hour, if the tricky creature doesn't take advantage of some underwater obstruction to snag the line and escape. The streams have numerous obstacles, some attributable to old logging practices, but most are natural windfalls too heavy to be flushed out by spring or fall freshets.

A majority of the steelheaders with big rods and spinning reels suspend their lures or bait less than a metre below a cork bobber and let it drift. (Roe, when permitted, is a favourite bait.) Other fisherman plunk that special lure, carefully weighed with pencil lead or just a lightweight silver spoon, into a pool, or cast quartering upstream and allow the lure to bounce down the riffles. There is a small fortune in lures that have snagged on the bottom or in overhanging branches, so bring plenty of spares. Steelhead sometimes tendermouth the bait, too often undetected, rather than slam in with a fierce strike. Experts claim it is the cold water that causes the fish to do this.

One of the local guides became a catch-and-release fan one day when he and his companion couldn't drop a hook into the Deena River without a steelhead darting away with it. Before that memorable afternoon was over the men landed and quickly released 36 fighting steelhead. "It was a once-in-a-lifetime experience," the guide told me, still amazed by their luck.

Lures are usually available in local stores, although the selection becomes pretty scant late in the season when all the hot ones are gone. So bring your favourites and buy some locally tested lures just to be sure.

Offshore or in most bays and inlets you should try jigging for lingcod, red snapper, assorted rockfish and halibut. A halibut may be large enough to snap your line or straighten the hook and escape. This fish always puts up one terrific tail-flopping fight before being subdued and boated. In any event, you will find halibut fishing a fun way to catch a good meal, even if it is not really

considered sportfishing. The jigger, usually a bright three-sided metal lure, slightly curved, weighing 170 to 595 grams (six to 21 ounces) and often fitted with triple hooks, is tied to a 22.5- to 90-kilogram (50- to 200-pound) test monofilament line and dropped to the bottom, hauled up about a yard, then worked by hand in lively jerking movements that raise the lure a little less than a metre each time. Halibut become violent when hauled near the surface or while boating them. That flat body is nearly all agile, flopping muscle, so completely subdue your catch before bringing it aboard. A pair of rubber gloves is helpful to grip the thin and slippery line.

Kelp patches or bottoms of sand, gravel or small rocks are generally recommended as places to jig for lingcod, red snapper, rockfish and halibut. Find on your chart the seamounts or banks that rise above the surrounding deeps, then locate them with a depth finder or hand lead or by triangulation. Fishing is usually best when the tides are moving and carrying feed past these bottom dwellers.

Life jackets or approved floatation clothing is required for all boaters. Oars, paddles, a bailing device and line and anchor should be standard gear in even the smallest skiff, and it is smart to mount a spare outboard with its own fuel tank. I learned that lesson off Copper Bay while urgently paddling a Boston whaler against a northwest wind and an ebbing tide for nearly two

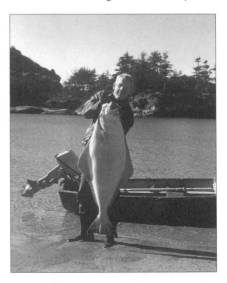

Will the skillet be large enough? The author with a 36-kilogram (80-pound) halibut caught on a jig. A boater equipped with a jig on a long hank of 90-kilogram (200-pound) test line is sure to catch plenty of lingcod, red snapper and halibut.

hours before reaching shore. And make sure to bring a portable VHF radio, another vital piece of equipment.

Crabbing is especially good on the sandy bottom along the northeast coast of Graham Island where Dixon Entrance and Hecate Strait meet. This is the area where commercial boats set their heavy traps for Dungeness crabs. Other good places for crabbing on Graham Island are Masset Inlet and Naden Harbour. On Moresby Island set your traps in Copper Bay or Security Cove. Waste fish or a punctured can of sardines is fine bait. Prawns or shrimp are taken in Masset Inlet, Naden and Thurston harbours, Tasu Sound, Skincuttle Inlet and other bays and inlets.

There may be days when you beachcomb or laze around camp until the tide is nearly out, then grab your trusty clam gun and dig up a meal of luscious razor clams from the long sand beach of McIntyre Bay on the north coast of Graham Island. These are great in chowders or roasted on a stick over a campfire. Best known locally and most sought after are these razor clams, which were once dug commercially but are now dug only by hand for personal use. These are the only clams permitted to be taken.

The harvesting of all other bivalve molluscs – clams and mussels – is prohibited throughout the Charlottes due to the possibility of PSP – Paralytic Shellfish Poisoning. The cause of this problem is a "saxitoxin 50 times more toxic than strychnine or curare," says marine biologist Darlene Madenwald in *Shellfish Roulette: The Red Tide Game*. Don't depend on seeing the red tide. The shellfish may be toxic before there is any visual alert. Butter clams, the most abundant species, are most likely to be toxic. Razor clams are seldom affected. On several occasions I have seen "blooming" *Gonyaulax dinoflagellates* so dense they made patches of the sea look like tomato soup. For further information concerning PSP as well as dioxin and furan contamination, call the 24-hour shellfish information line: (604) 666-3169.

As a conservation measure, the harvest of abalone is closed until further notice.

A number of boats are available for charter cruises in and around the Charlottes at daily or weekly rates. Some of these boats are skippered by long-time island residents who can pass along local lore and history while you relax or photograph unsurpassed coastal scenery and a rich variety of marine life, or just enjoy excellent salmon fishing. Some larger and more luxurious sailing or

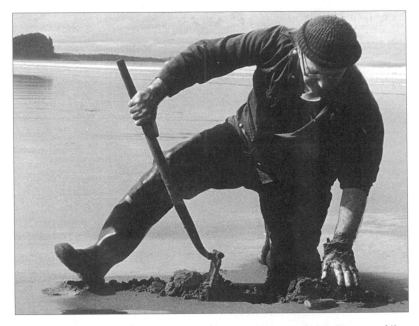

Sam Simpson, a pioneer island resident and expert razor clam digger, drops one of the delectable molluscs onto the sand of North Beach, Graham Island, a choice area for clam digging. Tow Hill, a distinctive landmark, looms in the background.

power vessels operate on scheduled tours, usually of 10 days or less, in and around the Charlottes during the summer.

Guides are usually not required for fishing or for hunting small game, game birds or waterfowl, but many visitors choose to use a guide or go with a friend who knows the territory. That person's knowledge may make the difference between a memorable trip with a varied bag of game or fish, and a trip that was only a pleasant outdoor excursion.

Nonresidents of British Columbia hunting big game – deer, bear and elk – must be accompanied by a licensed B.C. guide. Fees and regulations for hunting and fishing are subject to annual review and change. Sport anglers must have a valid licence in their possession when fishing for all finfish and crayfish in B.C. tidal waters. (Finfish are all fish other than shellfish and crustaceans.) A licence is also required for fishing in fresh water, as well as the supplementary steelhead licence and chinook conservation stamp. (For more information, see the **Recreational Directory**.)

4 Graham Island

By Car

Queen Charlotte to Tlell Near the centre of the Queen Charlotte Islands, the village of Queen Charlotte hugs the rocky shore of Skidegate Inlet. In this fishing and logging community of approximately 1,250 residents, you will find the island's general hospital and public health nurse, as well as the provincial and federal government offices. Also located here are an RCMP station, a regional library and a post office; the Gwaii Haanas National Park Reserve/Haida Heritage Site headquarters and visitor information centre; grocery, bakery, hardware, clothing, jewellery, variety and gift stores; churches, hotels/motels, bed-and-breakfasts, a credit union and cafés/restaurants; a floatplane charter and fuel services; glass, florist, heavy equipment repair, boat sales and repair, scuba, liquor and electronics sales and repair shops; garages, service stations, freight transporters and taxis; vehicle rental, travel and insurance agencies; laundry facilities; and a good boat haven. Service clubs include the Canadian Legion, Lions International, the Rod and Gun Club and Alcoholics Anonymous.

Over coffee or a meal at one of the cafés, you may meet some of the island residents and encounter the *mañana* attitude. Isolation was one of the reasons for this relaxed disposition. In the past residents used to wait at least two weeks, and often over a month, for supplies or replacement parts to be shipped

in from the mainland. Those who couldn't wait, or adapt, departed. While daily flights and frequent ferry service have reduced the transportation problem, much of this calm outlook has remained.

With exceptional year-round fishing, forests full of tender venison and a mild climate, you are likely to forget clocks and calendars and settle in to enjoy a relaxed life. In any case, the rhythmic and predictable flooding and ebbing of the tides will determine when you put your boat on the grid to scrape off barnacles and paint the bottom, when you dig for razor clams or when you hike past the white cliffs of Cape Ball.

Skidegate, formerly known as Skidegate Landing, is a small settlement around a tiny open bay between Queen Charlotte and the Haida reserve of Skidegate, once called Skidegate Mission. During the commercial fishing season, a buying barge is moored at the wharf in Skidegate. The float serves year-round as the Graham Island terminus for T & S Water Taxi (phone [250] 637-2237), operating from Alliford Bay. You will find this a necessary service after the ferry *Kwuna* ties up for the night at Alliford Bay, following its 10:30 p.m. trip from Skidegate. Alongside is the *Kwuna*'s all-tides vehicle ramp on Graham Island. Adjacent and to the west are the ferry terminal buildings, a loading area and the dock used by the *Queen of Prince Rupert* and the *Queen of the North*. Marine fuels and fresh water are available at the adjacent pier to

Aerial view of Queen Charlotte, on the southern shore of Graham Island. The log dump and booming grounds are in the foreground; beyond is the boat haven. The distant low point is Sandspit.

the east. This is the islands' only year-round source of marine fuels.

The Queen Charlotte Islands Regional Museum was opened by Prime Minister Trudeau in 1976. This architecturally harmonious wooden structure is located on the waterfront at Second Beach on the western edge of the Skidegate Reserve. Renovated and enlarged in 1988, its attractive exhibits include totem poles from abandoned Haida villages; a superb collection of argillite carvings, artifacts, wooden utensils, fur and bark clothing; household, school and farm equipment used by early settlers; natural history displays; whale skulls and fossils; photographs; and a well-stocked gift shop.

Nearby are Haida longhouse-style buildings sheltering totem poles, the Haida Gwaii Watchmen office and a workshop where new totems are carved. One structure covers *Loo Taas,* the 15-metre (50-foot) Haida dugout canoe seen at Expo 86. In June and July 1987, accompanied by powered escorts, this dugout was paddled from Vancouver to the Charlottes and beached at Skidegate, to the acclaim of hundreds gathered for a modern potlatch.

Some 700 Haida live on the rapidly growing Skidegate Reserve, a mixture of attractive new homes, weathered buildings, a hillside church, Co-op branch store, service station, one-hour photo service, snack bar, laundry and shower facilities, bed-and-breakfasts and a much-used community centre. On the waterfront and constructed in traditional longhouse style is a new office building enhanced by a tall dogfish totem pole designed and carved by noted artist Bill Reid, who was assisted by other Haida craftsmen.

Here and in Old Massett skilled goldsmiths and silversmiths create rings, bracelets, broaches, earrings and spoons of stylized design. Other equally talented artists choose to work with argillite, a soft, black slate found only in the nearby Slatechuck Mountain and reserved exclusively for the Haida. Argillite was probably first quarried and worked in about 1820, originally for household uses and curios, then for aesthetic expression, and now as a viable profession.

Still other artists fashion Haida hats and baskets of bark and roots or make silk-screen designs and prints suitable for hanging. All examples of Haida artwork are much prized by residents, visitors and museums. The works of Victor Adams, Gordon Cross, Robert Davidson, Rufus Moody, Bill Reid and other Haida have won international recognition.

Shortly before 1900 the few survivors of the dying Haida villages reluctantly abandoned their isolated ancestral homes and moved into Skidegate

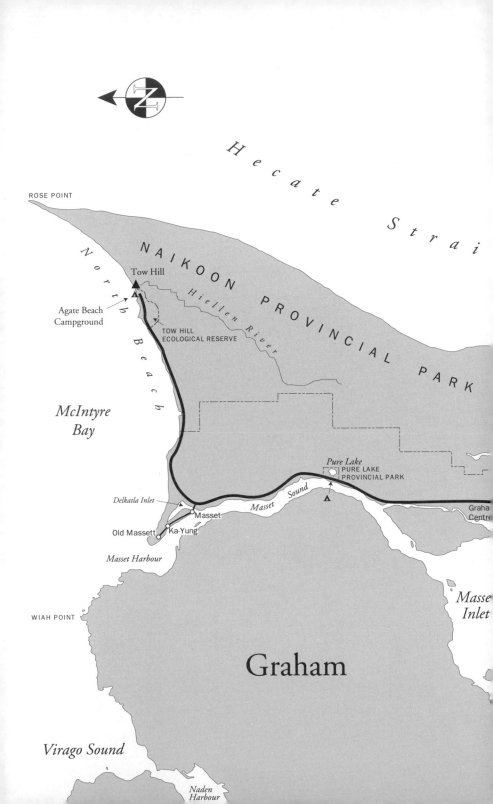

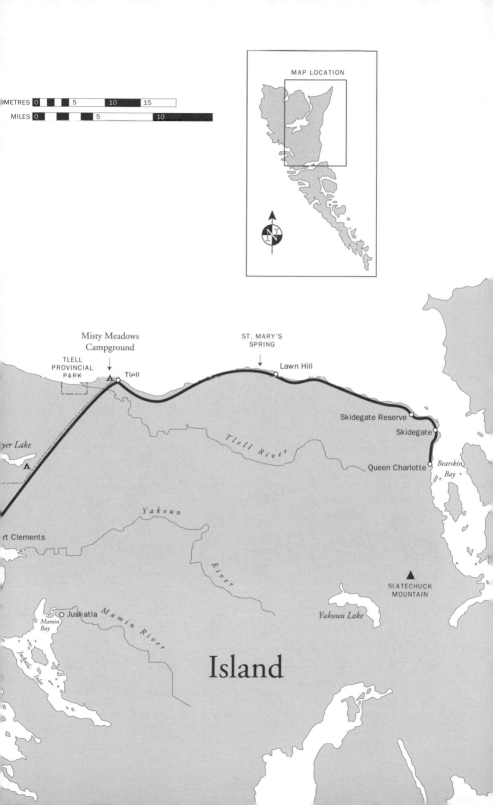

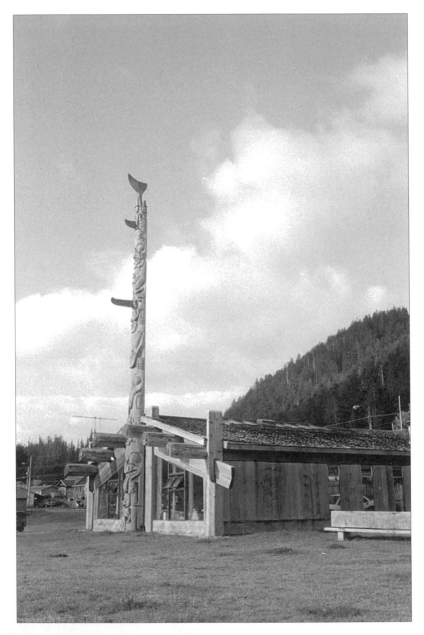

Skidegate Band office building with totem designed by Bill Reid.

Mission or Old Massett. The problem of too many chiefs and not enough villages was resolved by acknowledging the supremacy of the chief of Skidegate Mission and the chief of Old Massett, while recognizing the responsibility of the newly arrived chiefs for their own bands. This was the nadir of the artistic, sea-oriented Haida who only 100 years earlier had been estimated to number in excess of 8,000, living in at least 17 villages. By 1915 there were fewer than 600 Haida. Now there are about 1,600 living in the Charlottes. Other Haida, called Kaigani Haida, live across Dixon Entrance in the islands of southeastern Alaska.

To see the old village sites on Graham and Langara islands, apply at the Haida Council in Old Massett ([250] 626-3337). Permits for all Old Massett Band reserves are $15 per person. To visit the ancient villages on Moresby Island, obtain permits from the Haida Gwaii Watchmen office ([250] 559-8225) or the Gwaii Haanas National Park Reserve/Haida Heritage Site office ([250] 559-8818).

If you don't have your own boat, you can charter a boat, a helicopter or amphibian plane. Considering all factors, it might be economical to charter a four-passenger helicopter at about $800 per hour of flight time. For each hour of flight time you will usually have one to one and a half hours on the ground, plenty of time to explore serene mountain meadows bedecked with tiny wildflowers, beachcomb lonely shores that catch drift from far-off places or just go sightseeing, stopping to photograph whatever interests you. However, make sure you verify all flight and ground times with the pilot before chartering a helicopter. The popular Bell Jet Rangers cruise at 195 kilometres (120 miles) per hour. If your party is fewer than four, the helicopter base manager may know others who can fill the aircraft and share the cost.

The flat east side of Graham Island is the land of the homesteaders. Old trails and overgrown clearings mark disheartening failures. As the tranquility and wild beauty of the islands are rediscovered, visitors become residents and soon construct attractive homes along unspoiled shores and sequestered roadsides. New dirt roads or trails often lead through second-growth forest to owner-built homes of arresting design.

A two-lane asphalt road hugs the gently curving shoreline from Queen Charlotte to Tlell. Commercial fishing boats, tugs, log barges or a ferryliner can be seen on Hecate Strait whenever human-made or natural clearings reveal

vistas of the sea and rows of whitecapped breakers slamming onto driftwood-decorated beaches. To the west, dense second-growth forests are the main view. Some of this is ranch country where plodding Hereford cattle graze and deer browse.

Near Lawn Hill and on the road's seaward side a number of tall stumps have been transformed into birds and animals by the clever chain-saw sculpture of the late Ted Bellis. A short distance to the north is St. Mary's Spring, often a welcome stop for the thirsty traveller. Local legend has it that whoever drinks of this cool water will someday return to the islands. A Madonna, carved by Bellis, decorates this turnout. Davis Road, on the seaward side of the highway, leads to the Bottle and Jug Works, where appealing handcrafted pottery is created and sold.

Just 35 kilometres (22 miles) north of Skidegate Reserve, the scattered ranching and residential community of Tlell (nearly 400 people) nestles between a windbreak of low tree-covered dunes and the serpentine Tlell River. Turn inland on Wiggins Road for access to the Tlell River and to visit an art gallery and craft shops. A post office, stores and bed-and-breakfasts are located along the main road in this scattered community. An animal hospital, plus

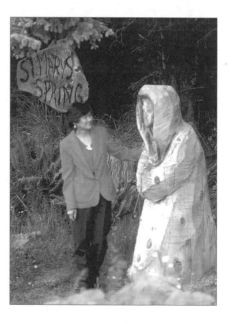

Visitor admiring Madonna at St. Mary's Spring along the road between Skidegate and Tlell.

boarding and grooming facilities, are available at the scenic Richardson Ranch. This homestead is a fisherman's dream: deep pools where salmon, trout or steelhead lurk are only steps from the kitchen doorway.

The headquarters of Naikoon Provincial Park are alongside the highway just south of the Tlell River bridge. Established in 1973, the park encompasses 72,640 hectares (179,500 acres) of the Queen Charlotte lowlands, which comprise most of northeastern Graham Island. A public phone is located near the headquarters building.

The park supervisor will provide you with a map of the park showing established trails, campgrounds or picnic sites. You may also learn whether tundra swans (formerly known as whistling swans), trumpeter swans, sandhill cranes or Canada geese are likely to be seen along the Tlell River lowlands.

Just north of the headquarters is Misty Meadows Campground, a pleasant spot where a picnic area, 30 vehicle campsites, 10 tent pads and a day-use cooking shelter, plus water and toilet facilities, nestle among the windswept trees. Campground hosts, usually retired islanders, are often on hand during the tourist season to provide information. Here, and in other provincial campgrounds, a small fee may be collected during summer. Primitive camping is permitted throughout the park.

At the approach to the Tlell River bridge, narrow, gravel Beitush Road breaks to the right, parallels the river and leads to the Tlell River House. The dining room of this quiet hotel overlooks a tidal portion of the river. Boat rentals and guided fishing tours are available.

On the northwest side of the Tlell River bridge is a parking and picnic site. A pleasant 16-kilometre (10-mile) round-trip hike begins here, goes through the dense rainforest and proceeds along the river to its mouth. Strike out across the wave-tumbled gravel where an occasional agate sparkles, then proceed onto the weathered bow portion of the wooden *Pesuta*. This 79-metre (260-foot) log barge was under tow during a southeast storm in December 1928 when it hit bottom, the towline parted and wind and seas drove it hard aground. Fortunately the tug escaped and no one was lost.

This enjoyable jaunt could be the start of a hike up the coast, fording small streams, passing a few cabins and coming out on the road to Tow Hill. It is an 89-kilometre (55-mile) hike if you use the Cape Fife Trail that cuts inland at Fife Point; 6.4 kilometres (four miles) longer if you round Rose Spit.

When hiking from south to north, the prevailing southeast wind will be at your back. Winds of 24 kilometres (15 miles) per hour are usual and are even more powerful during storms. Be aware of undertows along the beaches and at stream mouths. Water along the low area is brown and should be boiled before drinking. There is no sure source of potable water between Cape Fife and Tow Hill.

Tlell to Port Clements After crossing the Tlell River, the road turns inland, running nearly straight across about 22 kilometres (14 miles) of lowlands thinly covered with stunted trees. Dark, lazy streams snake through spongy marshlands. Blackened snags signal a long-forgotten forest fire. Deer browse along the right-of-way (and may leap in front of you), while above, eagles and ravens patrol, searching for roadkill.

Midway along the road on the right side is a one-kilometre-long gravel road leading to picnic tables, fire pits and toilets on the sandy shores of elongated Mayer Lake, where one can swim, fish, picnic or launch a small boat. Once, in mid-July, 19 common loons serenaded Betty and me with their haunting, yodel-like laughs as they swam and dived near the yellow water lilies in the lake's shallows.

The highway continues on to Port Clements, an early settlement on Masset Inlet – once named Queenstown – that is now a logging and fishing village with a population of nearly 600 people. Port Clements has a small boat haven and wharf, a general store, post office, motel and lodge, bed-and-breakfasts, cafés, churches, health-care office, service station, garage, taxi service, beauty salon, rock shop, variety and sporting goods stores, scuba shops and sawmill. Service clubs include Lions International and the Rod and Gun Club. Northeast of town is the site of long-abandoned Graham Centre, now the location of the Kumdis River Lodge, a year-round wilderness retreat that provides accommodations and meals.

In 1996 a pure albino raven was hatched, took up residence in Port Clements and has been proclaimed the village's official bird. It is quite tame and used to being photographed. Residents will usually know where this rare bird is and be proud to direct you.

For those travelling by RVs or campers, the village maintains a sani-station and freshwater supply. These facilities and electrical hookups are also available

at the Froese subdivision. Recent legislation has designated Port Clements as the centre to receive and dispose of solid waste originating throughout the Charlottes.

Port Clements was best known for its proximity to the Golden Spruce, a 49.5-metre-tall (165-foot-tall) tree more than 300 years old, with golden needles. In recent years other "golden" spruces have been discovered on the Charlottes, but this particular spruce on the west bank of the Yakoun River was the largest and most famous. In January 1997 the Golden Spruce was wantonly cut down by a man from off-island. Although this venerable landmark is no more, the lovely Golden Spruce Trail, winding among spectacular giant trees along the Yakoun River, is well worth hiking. It is located about 5.6 kilometres (3.5 miles) southwest of Port Clements. While hiking along the riverbank in late summer or early fall, you might see salmon working their way upstream to their spawning grounds.

After hiking the Golden Spruce Trail, take a drive west toward Juskatla for eight kilometres (five miles) and you will find a spur road on the left marked by the silhouette of a canoe. This single-lane road goes through a rapidly greening clearcut area to a wind-broken great western red cedar that was cut, chiselled and probed to its heart by the Haida. The carvers were testing the soundness of

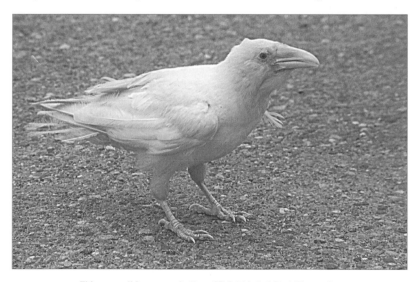

This rare albino raven is the official bird of Port Clements.

this tree that from the exterior appeared to be suitable for canoe building but, as it turns out, was not.

Nearby is a well-marked cedar-shake trail leading to a shaped but uncompleted dugout canoe nearly 15 metres (50 feet) in length. The Haida had to search the virgin forest to find large, straight red cedar trees for their canoes. Often, as in this case, a suitable tree was some distance from the water. The tree would be laboriously felled, chopped, split and burned out to lighten the log, then it would be dragged to water by many men. Carving was completed after the roughed-out canoe had been hauled ashore at the village.

To create a stable dugout with greater carrying capacity, it was filled with water, fire-hot rocks were tossed in to create steam and sticks were wedged from gunnel to gunnel to bend and gradually force the thin sides apart. The hot rocks also held the bottom flat, preventing hogging, that upward curving of the mid-bottom that destroys the craft's seaworthiness.

Gold was discovered in the vicinity of Juskatla-Port Clements over two decades ago. A pilot crushing mill was brought in and operated, then removed. After that the first phases of the Cinola Gold Project were completed. This project covered a broad spectrum of public concerns, including environmental studies, pollution control and job opportunities. The gold is there and the price is right, but the mine and mill were not started due to opposition by diverse groups. However, new owners, Misty Mountain Gold, will be drilling to five kilometres deep late in 1997 as they expand the search area and plans for development.

Port Clements to Old Massett When you return to Port Clements, continue on the smooth highway through this rolling and forested land. Nearly halfway along this 45-kilometre (28-mile) road to Masset is Pure Lake Park, a pleasant rest stop where public toilets stand near the road and picnic tables, fire pits and toilet facilities have been erected along the shores of lily-rimmed Pure Lake. Diminutive coniferous trees and low salal bushes add beauty and privacy to the area.

Masset is the Charlottes' largest village. A majority of its nearly 1,300 residents are employed in some facet of the fishing and logging industries. A canning and freezing plant along the east side of Masset Sound is the scene of great activity during the fishing season as professional fishermen hurry to unload their catches, take on groceries, chipped ice and fuel, then rush back to the fishing grounds.

Boat haven, Delkatla Slough, Masset.

The Canadian Forces Station at Masset has been greatly reduced, a serious economic blow to Masset and Old Massett. Many of the CFS homes, the recreation building and other assets, including timber, have been transferred to the Greater Masset Development Corporation. One of these houses might become your dream retirement home.

Masset has a visitor information centre (summer only), an RCMP station, a post office, a motel, bed-and-breakfasts, cafés, churches, physicians, a dentist, a public health nurse, garages and service stations, vehicle rental agencies, beauty salon, grocery, hardware, clothing, variety, liquor and gift stores, a public sani-station and a private recreational vehicle park with hookups. Emergency services are available at the Masset Hospital. Service clubs include the Canadian Legion, Lions International, Rod and Gun Club and Alcoholics Anonymous.

In late 1991 a handsome pole carved by Leon Ridley and apprentice assistants was raised at the George M. Dawson Secondary School. The Jessie Simpson Library is an attractive example of peeled-log construction and well worth seeing inside as well as out. Both of these may be seen as you drive along Collison Avenue. East of Masset is the municipal airport, 1,200 metres (4,000 feet) long by 30 metres (100 feet) wide and 7.2 metres (24 feet) above sea level. Expansion and improvements continue.

Tiny Delkatla Inlet reaches into town and is a fine boat haven filled with the local fishing fleet and sport boats. Harbour Air operates scheduled and

charter flights of floatplanes from Prince Rupert to Masset and, if there are passengers, to outlying logging camps at Naden Harbour, Dinan and McClinton bays and Eden Lake. Harbour Air operates other flights from Alliford Bay to Queen Charlotte, as well as to Prince Rupert.

A variety of waterfowl can be observed in Delkatla Wildlife Sanctuary at the head of Delkatla Inlet. The largest birds usually seen here are the rust-coloured sandhill cranes, which stop over during spring and fall migrations. Canada, snow, white-fronted and Ross's geese are all found here, too, as well as many species of surface-feeding and bay ducks. Coots, common snipe and mergansers add diversity to the ever-changing scene. In fall and winter numerous types of sea ducks are seen seaward of the boat haven. Scattered flocks of tundra swans winter in the Charlottes and trumpeter swans sometimes rest here. Early in 1995 the free flow of salt water into and out of Delkatla Slough was restored to improve the habitat for waterfowl.

About 3.2 kilometres (two miles) north, along the shore of Masset Harbour, some 700 Haida live in the reservation village of Old Massett. Here various styles of Haida art in several media are made and sold. In fact, the artist may even be on hand to explain the significance of your selection.

Nearby is the abandoned Native village of Ka-Yung where for many years stood a lone totem pole. Then, in 1969 Robert Davidson, a talented young artist, completed a tall totem honouring his grandfather, Chief Gungyah. At a large and festive gathering of local, mainland and Alaskan Haida, many of them clad in ancestral costumes, the handsome pole was erected near the Anglican Church to the accompaniment of traditional singing and dancing. Since then more poles have been added beside the village's grassy recreation field, just below the Ed Jones Haida Museum.

Shiny agates or red carnelian pebbles sparkle on the gravel beach beyond the village. Sometimes saucer-size scallop shells, sand dollars or glass fishing floats from Japan are found here.

Masset to Naikoon Provincial Park One should make the 26-kilometre (16-mile) drive along the north coast from Masset, past the Masset Airport, the Dixon Entrance Golf Course and the Canadian Forces Station, to Tow Hill. The first half of the road is good asphalt; the rest is hard-packed sand or gravel where planks, part of the old plank road, may be seen – or felt. The road wends past

Campers hiking the extensive shore of North Beach, Graham Island.

secluded year-round seaside homes and between trees bearded with lichens and heavy with moss. Signs indicating access to the long sand beach read: FOUR-WHEEL DRIVE RECOMMENDED.

Part of this area, where Spanish moss hangs like dainty lacework from the widespread branches of ancient spruce trees, is the Tow Hill Ecological Reserve. At the northeast tip of Graham Island is the Rose Spit Ecological Reserve.

With distinctive Tow Hill looming to the east and the active waters of Dixon Entrance in view to the north, you arrive at Agate Beach Campground where 41 vehicle and 10 tenting sites are available, plus fresh water, firewood and toilets. A roofed cooking and picnic shelter completes this pleasant and well-maintained spot. A fee is collected.

A short distance east is Tow Hill Picnic Grounds where tables and fire pits nestle under spreading spruce and cedar trees along the Hiellen River. Beginning near the shore is a winding trail that rises steeply to the top of Tow Hill's 120-metre (400-foot) cliff of columnar basalt. This is the second highest point in Naikoon Park and it is a good place to take photographs. On a clear day one can see beyond the restless waters of Dixon Entrance and across the

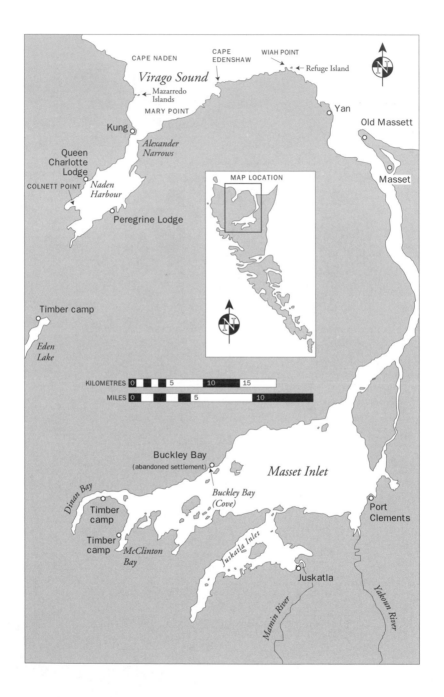

Canadian/U.S. border to the snowcapped mountains of Dall and Prince of Wales islands in southeastern Alaska. To the west, past the steel-blue waters of McIntyre Bay and low Wiah Point, lies the dark form of Langara Island. Some McIntyre Bay beaches are nearly 300 metres (330 yards) wide and are usually separated from the tree-covered dunes by a barrier of storm-tossed drift logs. To the east are the golden sands of North Beach, inviting one to hike the 13 kilometres (eight miles) of smooth sand to Rose Point. The Haida call this Naikoon, meaning "long nose." Continue along the shadowed and twisting trail and return to the picnic area.

Near Tow Hill is the Blow Hole, a natural tunnel in the basalt where, when tide and waves cooperate, a column of salt water is blasted upward with impressive sound and force.

The road ends at the beach on a Haida reserve along the east side of the Hiellen River. Although much of the damp sand is hard, it is quite easy to sink a two-wheel-drive vehicle up to its axles, and four-wheel drives should be equipped with a winch. The tide seems to rush in aggressively at such times. And, worse, you are miles from assistance or even a telephone.

Beyond is Rose Spit, an extensive finger of tidal sand where the changeable waters of Dixon Entrance and Hecate Strait meet in jumbled torrent along Overfall Shoal. Offshore you may see crab boats pulling in pots of choice Dungeness crabs or, at low tide, people eagerly searching the lower portion of the wave-lapped beach and digging for elusive razor clams, or hiking the upper beach and picking up scallop or razor clamshells.

The Cape Fife Trail starts east of Tow Hill and crosses the Argonaut Plain – an area of meadows, muskeg, meandering streams, stunted and wind-deformed pines and low, flat-topped hills – to Fife Point on Hecate Strait, a hike of 10 kilometres (six miles). A longer trail follows the Hiellen River inland to Clearwater Lake and on to Hecate Strait. These trails were upgraded in 1996.

Cruising the beach is recommended only for four-wheel-drive vehicles. Maps posted at access roads and campgrounds show the permitted routes within Naikoon Park. All are below the driftwood zone except for the marked route from the north beach to the east beach. For safety, two or more vehicles should travel together and carry emergency equipment such as winches, tow-lines and shovels, strips of metal matting or long boards and, of course, tide tables and first-aid supplies. A pocket-size VHF radio is also useful. Windblown

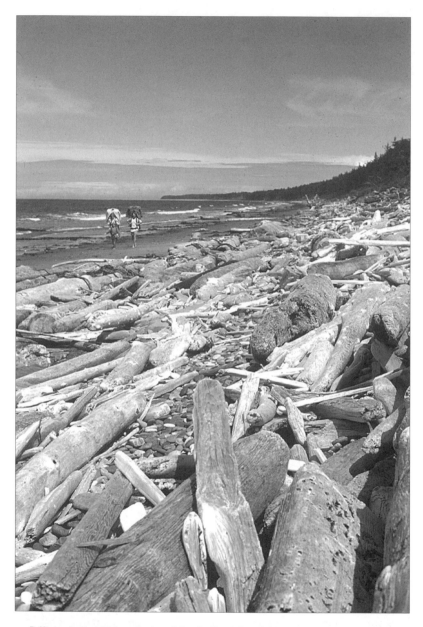

Driftwood piled high on Graham Island's North Beach. Weathervane scallop shells, razor clamshells and Japanese glass floats may also be found here.

sand can pit a windshield and damage a vehicle's finish, or sting the legs of people wearing shorts.

Whether on foot or by vehicle, you should enjoy the trip to Rose Point. The surf-packed sand of this curving beach gently slopes upward to a bulwark of aging silver drift logs. Winter storms shuffle old logs while tossing new ones and other ocean drift onto the grass-covered dunes of Rose Spit. Gulls, ravens and sandpipers make raucous company as you scan the shore for Japanese glass net floats or storm-dredged scallop shells.

Inveterate hikers or backpackers may want to turn south, down the east coast – possibly against the prevailing wind – along kilometres of sandy hills covered with coarse vegetation. Near the northeast tip of Graham Island is Argonaut Hill. It rises from the Argonaut Plain to nearly 150 metres (500 feet) above sea level. Flat-topped and wooded to its summit, this hill is one of the park's most prominent topographical features. Wild cattle, descendants of stock introduced by the pioneers, once roamed this desolate area. Cliffs of sand and clay at Cape Ball attain heights of 120 metres (400 feet), so don't get trapped against sheer cliffs by a flooding tide and pounding surf. The woods are interspersed with patches of swampland draining into small dark streams, some stagnant or brackish. This water should be boiled before drinking. Potable water is rare between Fife Point and Tow Hill, so pack a container of fresh water.

Your hike is nearly complete when you sight the stark, weathered timbers of the *Pesuta*. It is only five kilometres (three miles) more to the Tlell River bridge where, usually, a hiker can hitch a ride into town. One may expect to find more seashells, especially saucer-size weathervane scallops, than is practical to carry on the 74-kilometre (46-mile) trip. Lucky, sharp-eyed hikers should have a Japanese glass fishing float or two bulging from their packs.

Port Clements to Queen Charlotte After exploring the northeast end of Graham Island, you have to return to Port Clements on the same road you used to travel northward. At Port Clements you have a choice. If you wish to see the island's interior on your return to Queen Charlotte, head out of town on the logging road taken to see the old Haida dugout canoe (see page 41). Make sure that your gas tank is full and your spare tire is inflated. Only 19 kilometres (12 miles) southwest is Juskatla, local headquarters of MacMillan

Bloedel on Mamin Bay in Juskatla Inlet.

Note the log dump and sorting grounds where workers operating massive machines move great logs as easily as you or I would handle an armful of stove wood. Stop at the office to learn if the roads are clear of trucks and to pick up a free map showing the highway and hundreds of kilometres of logging roads on Graham and Moresby islands, plus campsites, picnic areas, boat launches, viewpoints and places of interest. You may be intrigued by some of the names: Ghost, Phantom, Canoe, Hoodoo, Blackbear, Blackwater and Gold creeks.

Sections of these roads are open to unrestricted travel; other sections are in use during working hours. Logging trucks *always* have the right of way on all logging roads, and you should expect them to take it. Tourists may have to resort to the ditch to prevent being hit by a gigantic truck loaded with up to 100 tonnes of logs, sometimes more.

You can also obtain a map at MacMillan Bloedel's shop near the west end of Queen Charlotte, or write to MacMillan Bloedel Ltd., Box 10, Juskatla, B.C., VOT IJO, and ask for their recreational guide to the Queen Charlotte Division. Information centres and government offices also have road maps.

If the roads are clear, backtrack a few kilometres until you cross the high bridge over the Mamin River, then turn south onto the main logging road that meanders through the broad valley of the Yakoun River and into the island's heartland. You will enjoy magnificent scenery while driving near a few of the valley's many enticing streams. The Yakoun River is one of the Charlottes' great salmon and steelhead streams. Anglers thrill to memorable encounters with the fighting fish spawned here. Haida of the Old Massett band enhance the Yakoun's chinook run with fry from their hatchery at Marie Lake. Commercial fishermen are sometimes allowed to take catches of thousands of pink or chum salmon from near the Yakoun's mouth after Ministry of Fisheries and Oceans officers have determined that all of the river's spawning beds are filled to capacity.

Sparkling streams pour into lakes fringed with freshwater lilies and nearly hidden in tracts of virgin timber or surrounded by second-growth trees of various ages. The road threads in and out between logged-off slopes, and spur roads may snake up hillsides to gouged earth and piles of broken timber, the scars and debris of cold-decking and truck-loading operations. Once waste, this wood is now utilized locally by specialty sawmills and shingle or shake cutters.

These clearcut areas, when reseeded by nature or replanted, quickly become cover and feed for birds as well as for deer and bears. In 60 to 80 years a new crop of trees will be ready for harvesting.

On Graham Island, MacMillan Bloedel provides a free bus tour starting from the Port Clements Museum at 9:00 a.m. every Tuesday and Thursday, May through September. Special tours may be arranged by calling (250) 557-4212. This is an excellent way to observe methods of modern logging, British Columbia's greatest industry, and see portions of Graham Island that you would be unable to drive to. It is advisable to reserve your place on these popular, informative, four-hour excursions that provide unusual photo opportunities in this northern marine rainforest. The tours cover log loading in newly cut areas, the dryland sort, forest management techniques, fisheries, wildlife, recreation and local history.

A raven flying directly from Juskatla to Queen Charlotte would travel less than 40 kilometres (25 miles). But the scenic drive from Port Clements to Queen Charlotte, rolling down the foothills of Slatechuck Mountain to Bearskin Bay and into the city, covers nearly 64 kilometres (40 miles).

By Boat

Masset Inlet to Lepas Bay Sailors arriving at the north end of the Charlottes during rough weather may want to quiet queasy stomachs by spending a few days cruising the restful, tree-fringed waters of Masset Sound and Masset and Juskatla inlets. (Because the various tidal streams can attain velocities of up to nine knots, check your *Sailing Directions: British Columbia Coast [North Portion]* before entering any area where the flow of salt water may be restricted.) Your *Canadian Tide and Current Tables* reference port for this Dixon Entrance area is Bella Bella. Watch as skilled operators aboard massive barges load over two million board feet of prime logs in less than 24 hours. A few barges are self-propelled; all are fitted with two or three towering cranes (self-loading) and tanks that are flooded upon reaching their destination, causing the barge to list and the logs to slide off with a great splash (self-dumping). Poke around the 75-year-old ruins of Buckley Bay (Cove). From 1918 to 1924 this was a sawmill settlement where 400 men were employed. It was also a freight/passenger stop

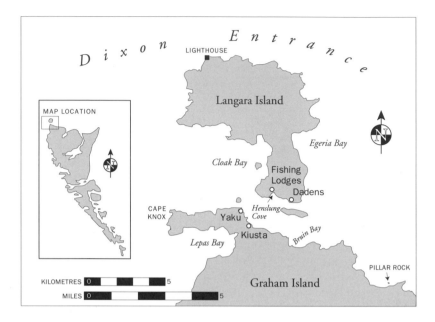

for the old *Prince John*. Cross to the neighbouring islands and search along the beach for fossilized wood.

Incidentally all mariners in and around the Charlottes should keep a sharp lookout for drifting logs and deadheads – water-soaked logs that have little buoyancy and often float vertically, sometimes disappearing below the surface for a few seconds, then driving upward, breaking the surface and projecting almost a metre into the air, or through a hull. Some deadheads rest on end on the bottom, their angled tops at or just below the surface, ready to joust with any unwary boater.

Beginning at Masset and cruising west, visit Yan, abandoned by the Haida before Newton Chittenden, an ex-Union cavalry captain, explored the Charlottes for the British Columbia government in 1884. He reported 20 houses and 25 carved poles here. The Yan Eagle was one of the most memorable of totem poles, with sparkling abalone-shell breast, curved beak and well-delineated feathers. It was an unforgettable pole in 1955 when we first saw it, although the abalone shells had long before dropped from the weathered wood. Cracked grey cedar totems, splotchy with moss and lichens, now merely hint at Yan's former splendour.

Fishermen talk of Seven Mile, but charts show the name Wiah Point. In any case, during the salmon fishing season, scores of trollers and gillnetters charge through the narrow passage between Wiah Point and Refuge Island to moor alongside the float for a too-short night's rest. While observing this evening ritual you might want to ask some of these self-reliant people what lies ahead on your westward cruise. Tie up next to the float, not outboard of a nest of trollers, for these boats will be under way before dawn to catch the "morning bite."

Heading westward along the low, nearly featureless north coast past Cape Edenshaw, you will find Virago Sound funnelling your vessel into Alexander Narrows toward the sandy beaches of Mary Point and the abandoned Haida village of Kung. Chittenden reported 20 poles, numerous graves and all but two of the 15 houses in ruins in 1884. One grave, now hidden in the trees, is marked with a marble monument. Here you will also find a rare and badly deteriorated triple pole.

This is the entrance to Naden Harbour, for 30 years, until 1943, home port for a fleet of whalers that before World War II kept over 100 Japanese

Pillar Rock, a 28.5-metre (95-foot) column of conglomerate rock and sandstone, is a conspicuous landmark on the north coast of Graham Island.

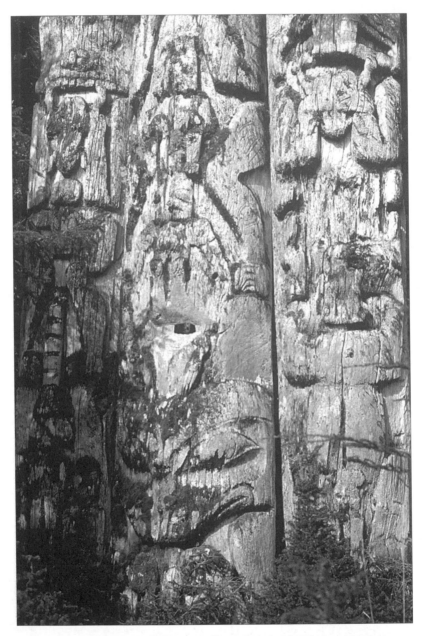

The rare triple totem at Kiusta, on the northwest end of Graham Island.

labourers busy flensing and processing massive carcasses into thousands of barrels of oil. A tall concrete tower stands on the western shore as a reminder of that bygone era. Today the handsome new Queen Charlotte Lodge is situated on the site of the old whaling station. On the harbour's east side is Peregrine Lodge. Both lodges cater to anglers seeking the big chinook, coho and halibut feeding in these chilly waters. Naden Harbour is also a good place to try out your crab or prawn trap. A fish head or punctured can of sardines is good bait.

A steel-hulled log barge has been sunk near Colnett Point, at the head of Naden Harbour, as a breakwater for the booming grounds. A private hauling road extends south through the broad Naden River valley to a modern trailer camp for employees of the logging company operating on the shores of Eden Lake. This is Canada's westernmost logging operation. A small specialty sawmill, utilizing portions of logs that otherwise would be uneconomical to ship out, operates near the Naden River. Mooring buoys have been anchored on the southern side of the Mazarredo Islands, located on the western side of Virago Sound.

Nineteen kilometres (12 miles) west of Cape Naden is Pillar Rock, rising 28.5 metres (95 feet) above a tidal ledge. This unique and picturesque column of conglomerate rock and sandstone – eight metres (26 feet) in diameter – is covered with a headdress of brush and small trees. A pair of Peale's peregrine falcons have nested on this sheer rock, safe from enemies and overlooking an ample supply of seabirds. This distinctive breed of falcon is often seen and heard along the Charlottes' lonely coasts. Mooring buoys are located in Pillar Bay.

West of the mooring buoys in Bruin Bay is an opening on the southeast side of Marchand Reef (more mooring buoys), affording access to a gravel beach in front of sad-faced totems at the twin abandoned Haida villages of Kiusta and Yaku. Located at Kiusta is the triple mortuary pole of Chief Edenshaw. Carefree children once played in the grassy clearings where deer now browse and trees are returning.

After an encouraging exploratory dig at Kiusta in 1972, archaeologists returned a year later with a crew of two dozen young assistants and began excavating. A number of Haida artifacts were discovered, identified and catalogued during the winter. Further excavations have been made since then. Weathered totem poles, an old cannon and most of the artifacts found at Kiusta are on display in the Ed Jones Haida Museum in Old Massett.

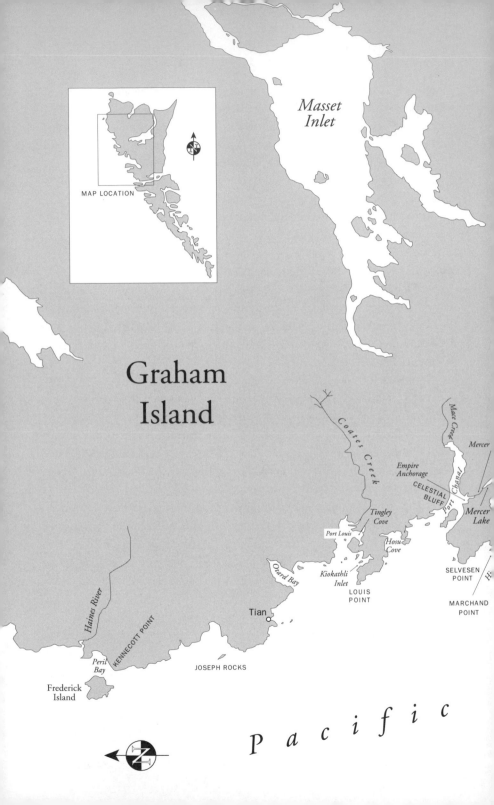

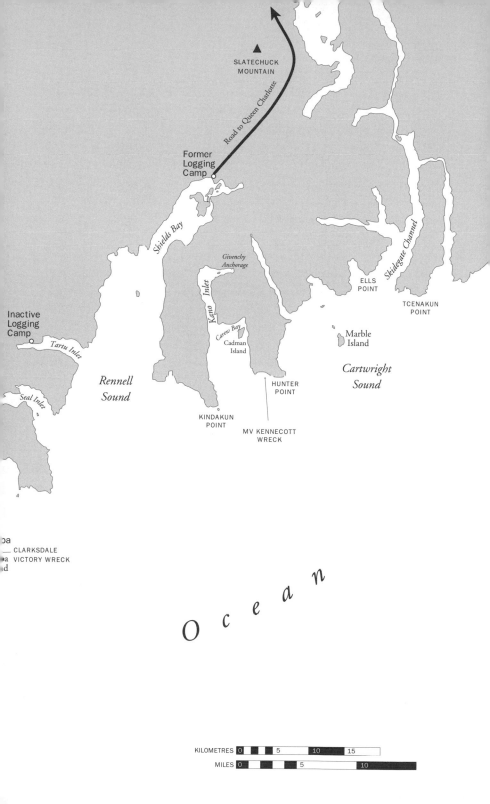

SLATECHUCK
MOUNTAIN

Road to Queen Charlotte

Former
Logging
Camp

Shields Bay

*Givenchy
Anchorage*

Kano Inlet

ELLS
POINT

Skidegate Channel

TCENAKUN
POINT

Carew Bay

Cadman
Island

Marble
Island

*Cartwright
Sound*

Inactive
Logging
Camp

Tartu Inlet

HUNTER
POINT

Seal Inlet

*Rennell
Sound*

KINDAKUN
POINT

MV KENNECOTT
WRECK

a

CLARKSDALE
VICTORY WRECK
d

O c e a n

KILOMETRES 0 5 10 15

MILES 0 5 10

A short, well-blazed trail follows the forested valley between Kiusta and crescent-shaped Lepas Bay. This sandy west coast shore is a fine place to search for Japanese glass balls tossed ashore by rows of breakers slapping the beach. Here also is the place to begin a southward hike of a few days along the relatively low, often sandy shores to Peril Bay. Always notify a responsible person of your intended route and scheduled date of return. This stretch of the coast is difficult for boats or floatplanes to land on except during infrequent times of calm seas. A helicopter is the surest way to get in or out of here.

Langara Island Swift peregrine falcons and their prey, auklets and murrelets, nest on the rocky and precipitous coast of wooded Langara Island. Other birds abounding in this remote area are bald eagles, belted kingfishers, pigeon guillemots, murres, glaucous-winged gulls, surfbirds, black turnstones, black oystercatchers, mergansers, loons and a wide assortment of surface-feeding and bay ducks.

Circumnavigation of Langara Island is well worthwhile, especially if it includes a visit with the lightkeepers. A few lights are still maintained by a family

PHOTO: DR. PETER MYLECHREEST

Hosu Cove, Graham Island. The author and his wife, Betty, beachcombing and storm watching during a northwest gale.

or two; most, however, have been automated. I have always found the keepers hospitable and eager to tell of their unusual and interesting work. However, landing near a lighthouse is often difficult, and a skipper may choose to remain aboard.

If thoughts of dining on tasty, freshly caught salmon activate your salivary glands, you might troll along the north side and down the east of Langara past Egeria Bay. Your meal could be ready before reaching the mooring buoys in Beal and Henslung coves, west of the abandoned Haida village of Dadens. Commercial fishermen here are a ready source of information concerning sea conditions to the west, although they may toss in a few barbed remarks about the sanity of anyone who would choose to spend a holiday on the Charlottes' wide-open, uninhabited west coast with its quickly changing weather.

From May through mid-September North Island Lodge and Langara Fishing Lodge, plus one or more large charter vessels, are based in Henslung Cove. Before dawn until after dusk their numerous boats rush to and from the cove as eager anglers on three- to five-day outings compete for large chinook, coho and halibut. In 1993 the largest halibut caught in British Columbia – 145 kilograms (320 pounds) – was hauled in by a fisherman from Langara Fishing Lodge.

Rats that destroy birds and their nests have been a problem on Langara and Lucy islands for many years. For weeks in 1994, and again in 1995, a group worked to exterminate these rodents whose ancestors abandoned supply ships perhaps a century ago. Tests in 1996 and 1997 indicate that the program was successful.

Langara Island to Tian Your *Canadian Tide and Current Tables* reference port for the Charlottes' west coast is Tofino. Black reefs of eroded volcanic rock alternate with smooth, sandy beaches along Graham Island's wild west coast. Landing is seldom feasible on many of these open, alluring, agate-speckled beaches, but when seas are calm rewards for photographers and beachcombers are great. Among the treasures found here have been long bamboo poles up to 15 centimetres (six inches) in diameter, notched and fitted with line for use on Oriental craft; tall, tapered saki bottles; glass fishing floats, some larger than basketballs, a few wrapped in colourful net or plastic covers; life rings painted with the names of ships and distant ports of registry; wooden kegs bound with strips of rattan and redolent of soy or pickled daikon; large Oriental crockery

jugs of the type used to age sweet rice wine; and plastic or tin containers with Japanese or Russian labels.

Occasionally a dead whale or shark washes ashore. Most have died of natural causes; a few due to encounters with ships or killer whales. After bears and eagles have feasted, the bones break apart and are scattered by storms. Bones endure for years and may be found on any shore. The banana-size teeth of sperm whales are prize finds. The carcass of an orca, complete with skull and teeth, was found in Kaisun Harbour in 1987. More recently three grey whales drifted onto Graham Island's north and east coast beaches. Whalebones are a common sight in yards, on porches or near business establishments.

With keen eyes, great luck and kilometres of hiking lonely beaches, you may find some of these treasures, even shark teeth. I am happy if I pick up one whale tooth every two or three years. One summer, on a west coast beach where I had once found a sperm tooth, I discovered a harpoon. Its nose cone had exploded and its four barbs were rusted open. Even though it was heavy and unwieldy, I didn't leave it behind. Fury Bay's gravel beach may yield a few more sperm teeth to a diligent beachcomber.

The varied and fiercely beautiful but often inhospitable shores between Henslung Cove on Langara Island and Port Louis on Graham Island are the

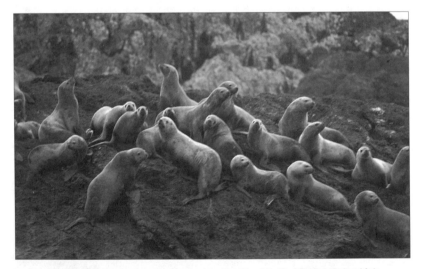

Sea lions haul out on ocean-scoured rocks. About half of British Columbia's approximately 5,000 sea lions feed and breed in the Queen Charlottes.

longest stretch on the Charlottes' west coast unbroken by any sheltering inlet. Lepas, Sialun and Beresford bays are enticing, but row after row of building, cresting and breaking waves charging up wide, gently sloping beaches of golden sand make landings difficult and launchings dangerous. Even after an easy landing, stay alert for a change in the sea, especially during the rambunctious flood tide. Hiking or helicoptering in are the safest methods.

White Point is easily recognized by its high white cliffs. A wide, flat tidal reef still holds the anchor chain, bitts and other metal parts of the American halibuter *Weiding Brothers,* wrecked before World War I. Haines Creek, on the northeast side of Morgan Point, can be entered by shallow-draft boats at high tide during calm weather. I have anchored overnight just behind the sand point inside the creek's mouth.

The rolling waters off Frederick Island, which has mooring buoys on the northeast side, offer indifferent protection for the sailor resting overnight or waiting out a storm. Eastward of the island is conspicuous Beehive Hill and the aptly named Peril Bay (shallow, windy and poor holding ground), where a wide beach of loose sand curves to the rocky ledges of Kennecott Point. South of the point a loose gravel beach, pinched between a wide flat reef and upswept banks, glitters with cloudy agates, some larger than baseballs. Jet-black fossilized wood from prehistoric trees is often uncovered by churning seas.

If you are interested in finding agates, Cave Creek is the place to land. With caution, quiet seas and a half tide or more, it is possible to enter the outflowing stream. Rock spires project from the active water on the north, and a steep bank of loose gravel rattles on the south. The seldom peaceful ocean has tumbled these agates until they are smooth and bright.

A colony of nearly 400 sea lions hauls out on sea-washed Joseph Rocks. Approaching slowly, a visitor can get within camera range while great bulls weighing up to a tonne each belch and order the much smaller females off to investigate. When the observer gets within 100 metres (330 feet), the rocks become a mass of slithering brown bodies caroming pell-mell into the sea as the females seek refuge from the human visitor. Finally, with obvious reluctance, the truculent bulls gracefully arc into the foaming waters. Slim heads pop out of the water and the sea lions roar until the intruder leaves. Then, surf-riding with superb agility, the animals return to their slippery rock and interrupted rest.

Of the approximately 5,000 sea lions along the British Columbia coast, more than half find shelter and food, mostly scrap fish, in waters around the Queen Charlottes. In midsummer of 1974 scientists from the University of British Columbia tagged 263 sea lion pups born on the rocks off Cape St. James at the southern tip of the Charlottes. *It is illegal and senseless to shoot any marine mammals.*

Nearly a dozen weary totems, many split by trees and shrubs rooted inside them, lean among second-growth trees surrounding rectangular excavations where great longhouses once stood on knolls at the abandoned Haida village of Tian. Even today it is easy to fathom why the ancient Haida loved this sunny village, built near salmon streams and only minutes away by dugout canoe from banks teeming with lingcod and halibut and well protected from raiding parties by many miles of open sea. Lying in the village are tangled wire rope, stacks of drill rods and a small steam engine, all flaky with rust. Nearby is a 15-centimetre (six-inch) pipe burbling brackish, sulfurous water – the futile end of a pre-World War I search for oil. Numerous seabirds nest on the rough and grassy Tian Islets. To the east is open Otard Bay. The tea-coloured Otard River may be entered at high tide by small boats or kayaks and one can camp on the high sand beach. A now overgrown trail once led to Naden Harbour.

Port Louis to Hippa Island If you are caught in a summer fog or stormbound for a day or so (and this can happen in summer when a local gale may strike without warning and water tumbles from the hillsides in many cascades and runnels), Port Louis, Port Chanal or Nesto Inlet are snug places to be anchored or moored. There is always plenty to do for crew members of all ages. In fine weather it is too easy to hoist the anchor and promise yourself a better look next time. In summer the North Pacific highs can lie off the Charlottes' west coast for more than a week at a time causing northwest winds of 15 to 30 knots to build big rollers or cresting breakers that make cruising south fast, and beating northward slow and uncomfortable.

Tingley Cove in Port Louis is a secure anchorage, but watch out for the rocks outside. From near here you can hike the kilometre-long road leading west from an abandoned loading pier to a cleared and levelled area of about a half hectare where, in 1971, the Union Oil Company drilled to 1,500 metres (5,000 feet). Or at high tide you can run your power skiff up to the chattering

falls of Coates Creek, fishing along the way. In the mid-1980s a fish ladder was constructed at the falls and every year Coates Creek is enhanced with coho salmon fry. Hunt or photograph deer feeding in the grassy flats. Walk kilometres of varied shores, beachcombing or rockhounding. Comfortable cabins have been built within the shelter of Port Louis. Agates and red jasper, surf-tumbled and smooth, abound on a sequestered beach just northeast of Louis Point.

It is only a short hike from Kiokathli Inlet (mooring buoys) across grassy, sparsely treed lowlands to wildly magnificent Hosu Cove. During a westerly storm this rock- and reef-cluttered cove is frosted with scudding foam tossed from rampaging breakers. If you are lucky and catch the sea reasonably quiet, Hosu Cove is worth hours of exploration by boat and afoot. Although not properly surveyed and encumbered by islets and many underwater hazards, you can, with care, "read" the water and enjoy Hosu's numerous tiny bays with beaches of sand, gravel or boulders – sheltered between headlands of rough, angular rock or hidden behind narrow islets – all sloping up to the windblown forest crisscrossed with game trails. A small stream empties through a long gulch at the northeast side.

The mooring buoys at Port Chanal are a good base for exploration or for fishing for halibut and lingcod. The photogenic islets and rocky point between Empire Anchorage and the buoys lie within the borders of an ecological reserve. Nearby is Mercer Creek, a short, winding stream tumbling through a valley of old spruce and cedars. This creek is the overflow from Mercer Lake where sockeye salmon return to spawn each summer. Rock hounds should find a few pieces of fossilized wood during a jaunt over the stones of Mace Creek at the head of Port Chanal. Caves along the north shore, beyond Celestial Bluff, will entertain any spelunkers among the crew. You may also see the fast-flying peregrine falcons and hear their slurred notes in this region.

In the unnamed and incompletely surveyed bay between Selvesen and Marchand points, grotesque rock formations, arches and sheer, battered cliffs rim a rocky bay. Ragged, gale-torn trees climbing tall, snow-covered mountains make excellent subjects for many pictures. Even in quiet weather the seas surge powerfully in and out of most narrow leads to the shore.

Nesto Inlet, entered from Hippa Passage, is good shelter, has excellent fishing and can be your base for investigating the many sandy beaches pinched between fingers of rock along the north side of the passage. Haida once lived

in this area, although no totems exist here today.

Betty and I were moored in Nesto one June when a large black bear ambled out of the bush to feed on tall salt grass near the stream. Soon he walked over to a small spruce tree, stood up to his full height, grasped a limb high overhead and commenced scratching his back against the trunk, shaking the entire tree. Another time, during salmon spawning season, four bears were fishing at the stream's mouth. One large fellow failed to snag a fish in his teeth. Finally, frustrated and hungry, he leaped from a rock into the shallow pool where many salmon congregated. Spray flew in all directions as he hit the water with a mighty belly flop – and still no salmon for dinner!

Pull a skiff ashore on Hippa Island and spend a day hiking. Search for signs of a World War II coast-watch cabin as well as abandoned Haida lodges on the northeast shores. If the sea is smooth, it is possible to enter the tiny bay on Hippa's southwest side. I have anchored there for the day a couple times, and a friend with a 15-metre (50-foot) yacht has also dropped anchor there, but not overnight.

High on the shelving reef on Hippa Island's south side is the bow section of what was once a U.S. Army transport ship. Powerful storms continue to shove it landward. At low tide one can climb aboard and walk along canted decks thick with rust and littered with broken anchor chain and freight-handling gear. Cargo booms fitted with heavy blocks hang over the side, trailing whiskered rigging. Departing Whittier, Alaska, in November 1947 the *Clarksdale Victory* went aground and then broke in two. All but four of the ship's crew of 53 perished during the gale, while U.S. Coast Guard planes and ships from Alaska fought wind and sea, trying to reach and rescue the seamen.

Rennell Sound to Skidegate Channel Salmon trollers ply the semi-sheltered waters of Rennell Sound, which is bounded by snowcapped mountains and reaches 29 kilometres (18 miles) into Graham Island. A private logging road branches off the main route between Queen Charlotte and Juskatla and may be used on Sundays or after working hours. This road goes through a low mountain pass and down a steep hillside to Shields Bay, where anglers launch their boats and try for salmon or bottom fish. Along the sound's north side are improved campsites. Residents and tourists are increasingly finding this area attractive for fishing, camping and sightseeing. If necessary, you could hike

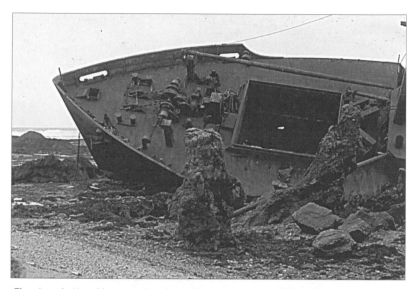

The storm-battered bow section of the *Clarksdale Victory* on Hippa Island. Swept about 40 kilometres (25 miles) off course and without radar, this U.S. Army transport ship ran aground on a November night in 1947. Forty-nine of the 53 men aboard were lost.

and hitchhike to Queen Charlotte from here.

If you don't care to go to the head of Rennell Sound for a safe anchorage, you might try Seal Inlet. Although its entrance is littered with rocks – seen and unseen – one can find shelter at the inlet's head near extensive grassy flats and amid interesting islets. Or go past Seal Inlet to Tartu Inlet and tie up at one of the mooring buoys. A truck logging camp operates here and has constructed miles of roads you may decide to hike.

During the uncommonly stormy winter of 1902-03, a sailing ship was wrecked on the bouldered shore between Rennell Sound's Cone Head and Kindakun Point. Bill Hill, a helicopter pilot, told me about an anchor here. In May, after Betty and I waited nearly a week in Kano Inlet for the seas to calm, she was able to row ashore and land. *Skylark* and I bounced in the waves while Betty found the anchor and a number of deadeyes. By the next day the sea had calmed and both of us landed. With pictures, more deadeyes and metal pieces, we were ready to attempt identification of the wreck. An elderly Haida chief gave us a few clues, but it wasn't until 1973, after extensive research, that Betty and I identified the burned remains as the 67-metre (220-foot) *Florence*.

Some of the "treasures" of a beachcombing hike.

Unheard of for months after departing Puget Sound with a load of coal for the Oahu Railroad in Hawaii, this three-masted sailing ship was at last logged "missing at sea, all hands presumed lost."

In July 1973 we worked with the owners of a log salvage tug to recover the ship's rare Trotman anchor. In June of 1985 we assisted 11 members of the Duncan family in the recovery of the *Florence*'s second one-tonne anchor. These were great- and great-great-grandchildren of Fred Duncan, captain of the *Florence* for 14 years, but not at the time the ship was lost. This time a helicopter was used to recover the anchor after thorough planning. Both days were long and exciting, filled with arduous work and blessed by reasonably calm seas.

Part of your crew might enjoy lolling on one of the sand beaches, just a short swim from the mooring buoys in Carew Bay, near the entrance to Kano Inlet. The rest of the crew might shove off to jig for cod near Cadman Island. Givenchy Anchorage at the head of Kano Inlet affords good shelter and has a mooring buoy and freshwater hose, plus a fine view of steep mountains.

Foul ground and extensive kelp beds surround Hunter Point, where massive boulders grip a few twisted frames and plates from the MV *Kennecott*. Just to seaward, at low tide, the vessel's diesel engine can be seen. This U.S. ship was destined for a Tacoma, Washington, smelter with 6,000 tonnes of high-

grade copper ore from Cordova, Alaska, when fall currents and a northwest storm combined to set the ship east of its course and caused it to run hard aground one night in October 1923. Similar sea conditions in 1964 parted the thick towline of the Portland-bound supply barge number 539 and set it almost on top of the *Kennecott*. Large tires mounted on heavy rims, rusted oil drums and tanks for compressed oxygen and acetylene are all that remain, and these have been well scattered along the Charlottes' west coast. No lives were lost in either disaster.

An unmanned coast guard radio site was completed on Hunter Point in 1988. Those with a small boat or kayak can land on the point during calm weather and be rewarded by outstanding beachcombing. Seas offshore are often confused, especially shortly after the tide turns. Conditions improve after you round the long, shelving reef and turn into Cartwright Sound. This is an excellent place to troll for salmon, jig for halibut or relax ashore and hike the drift-laden beaches.

Remains of a World War II radar station are found in a semi-sheltered pocket on the north side of Marble Island. Green camouflage paint splotches the siding of a gale-flattened mess hall, barracks and workshops. Almost lost in thick brush is a funicular hoist and decayed steps leading to the weather-beaten tower and hilltop barracks. If the weather is clear, the climb is worthwhile because of the superb view of the surrounding seascape. However, landing on Marble Island is never easy, even during calm seas, because of the powerful surge.

Excellent fresh water may be obtained year-round from a hose at the buoy near the head of Dawson Harbour where, during the fishing season, commercial fishermen congregate at night. A large sportfishing mother ship may be anchored here during the summer, and its many small boats will likely be working near the entrance to Skidegate Channel and out to Marble Island, especially for bottom fish. Sportfishing boats from Queen Charlotte and Sandspit may be plying these waters nearly year-round, especially in the vicinity of Tcenakun (Skidegate) Point.

Tidal streams of up to seven knots are created in the narrows between Graham and Moresby islands due to tides at Queen Charlotte, on the east, ranging to nearly eight metres (25 feet) on a large tide, while tides west of Trounce Inlet range to a little over four metres (14 feet). On one's first passage

it is advisable to enter on a flooding tide. Slack water occurs about three hours after high or low water at Queen Charlotte. Check your chart and *Sailing Directions: British Columbia Coast (North Portion)*. Concentrate on piloting your boat through this narrow sluiceway while other members of your crew stay clear of the pilothouse and snap pictures of the glorious scenery and a variety of waterfowl.

Even experienced skippers may run afoul when tidal forces are near maximum. In mid-July, 1987, from a helicopter, I photographed two 15-metre (50-foot) seiners near the west end of the narrows. One was hard aground on a gravel bar, with the tide ebbing rapidly. The other lay on its beam ends, flooded, with seine net and floats swirling around its stern. All hands were rescued and the vessels refloated. The canted hull of *Blue Moon,* another seiner, rests on the Moresby Island shore just east of the mooring buoy.

As you make the passage, deer munching kelp may keep a wary eye on you. A bear might amble along the shore, turning over rocks in its search for food. Overhead a pair of eagles may ride a convection current. Ravens may playfully soar and perform intricate acrobatics. Fat ducks intent on escaping your boat will run along the water, wings beating frantically until, looking like overloaded seaplanes, they become airborne. Salmon may leap and splash and seals may surface for a quick look at your vessel. With luck, you might fall astern of a homeward-bound fisherman and thus be piloted through.

Before mooring at Queen Charlotte or in Sandspit's new small-boat harbour to pick up mail, do the laundry, restock the food locker and even splurge on a meal ashore, you might consider landing on the rocky west beach of Lina Island to search among tidal rocks for petroglyphs. Fuel for boats is currently available only at Skidegate, east of the ferry landing, and in Masset from a barge moored at the government pier; probably a summer-only operation.

Anyone travelling around the Charlottes by sea, land and especially by air will notice many lakes, large and small. After studying these lakes and their fish for nearly two decades, Dr. Tom Reimchen reports that there are about 1,000 lakes of one hectare or greater in size and approximately 250 of these contain one or more species of fish.

5 Moresby Island

By Car

Moresby Island is great for the boater, but for the hiker or motorist most of it is less accessible than Graham Island. It has fewer than 30 kilometres (18 miles) of public road. Half wind along Skidegate Inlet from the Alliford Bay ferry ramp and separate water taxi dock to Sandspit; the remainder is within Sandspit. Fewer beaches are accessible to drivers or hikers along Moresby's ragged and varied east coast. Unfortunately for most would-be visitors to Gwaii Haanas National Park Reserve/Haida Heritage Site, vehicle access does not exist and never will. Barriers of mountain and sea are too great.

After stopping at the visitor information centre in Sandspit to orient your-self and get the latest word on what to see and do, drop in at TimberWest Forest Ltd. Tourist Information Centre and pick up a free map and copy of "Forests for Our Future." If you can't get to the office, phone (250) 637-5436 or 637-5323. During summer they offer facts about silviculture, clearcutting, wood products and safety on the logging roads. It is hoped your visit to the islands will be safe and pleasant. Do your part: obtain permission before enter-ing industrial logging roads; find out what route the monster logging trucks are taking and avoid those roads; do not enter active logging areas; use your map (without it you could get lost in the maze of gravel roads that look much

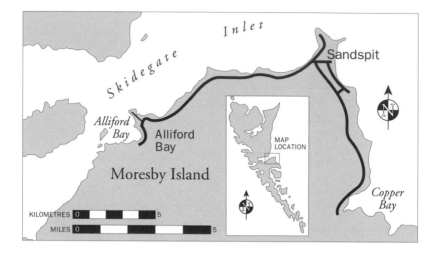

alike); and drive with your headlights on so that you will be spotted sooner.

TimberWest's 11-kilometre (seven-mile) road between Sandspit and Copper Bay is always open to public use. Hundreds of kilometres of new and old logging roads may be used after working hours or on most weekends, but check at the office first. Main roads currently in use are usually well graded, although narrow. Roads in logged-off areas where a new crop of timber is growing are often edged with young alders. Many have been intentionally closed by the removal of bridges and culverts or blocked by a spring washout or a storm-felled tree. Some roads wend along broad valleys, often crossing gentle trout or salmon streams. Branch roads climb to hillside spots that are suitable for camping and overlook tranquil lakes or sheltered inlets surrounded by steep green mountains. Ravens, eagles, deer and perhaps a bear are usually seen in these regions.

A pleasant day may be spent on a road known locally as the Loop. Drive south from Sandspit, past the golf course and along the shores of Hecate Strait, where weathering drift logs create an obstacle course to the gravel beach. Fist-size, sea-cleansed moon snail shells are often found along these beaches. Perhaps a pair of ravens will guide you along this avenue overhung by lush second-growth timber, and then on to shallow Copper Bay where, from August through October, salmon fishermen test their skill and luck. A boat launching

ramp is located here. At the head of the bay are a number of modest cabins owned by Haida from Graham Island and used when the Natives are engaged in netting and smoking their fish supply from April to November.

The gravel road curves through the valley, often within sight of the rushing Copper River where dedicated anglers try for salmon, steelhead and trout. A sign at Spur 20 points the way to Gray Bay. Nearly two dozen campsites, well scattered to preserve privacy, have been built along the crescent bay's sandy shore. Salmon are often caught here, from shore or from boats. A beach trail to Cumshewa Head starts at the road's end.

Another hiking trail a little more than a kilometre in length begins at Spur 29, marked with an information sign and a parking area. Picnic tables and toilets are provided. You may see a doe and fawn or a spruce grouse and her chicks in this region.

When you approach Skidegate Lake, you will see blackened snags, some pointing skyward in weird configurations. This is the area where the Charlottes' most destructive fire of contemporary times took place. In the dry summer of 1957 a fire started in a large area of freshly felled and bucked timber. Quickly it burned out of control, destroying hundreds of thousands of dollars' worth of logs. Nature reseeded this land where birds, deer and bears now thrive.

A few kilometres beyond trout-filled Skidegate Lake is the Moresby turnoff, leading to Mosquito Lake, another favourite trout fishing spot. A boat launching ramp, campsites, toilets and picnic sites are maintained along the shaded shore. The lake was once used for log storage and sorting. Now a few deadheads break the dark surface, providing handy perches for belted kingfishers.

Mosquito Lake wasn't named after the pesky insects but for those versatile twin-engine Mosquito fighter-bomber and reconnaissance planes of World War II. Much of the strong, lightweight spruce wood used to construct these planes in Canada and England came from the Charlottes.

A salmon hatchery, open to visitors, is operated along Pallant Creek between Mosquito Lake and Moresby Camp. This is part of the federal government's multimillion-dollar Salmonoid Enhancement Program, which is dedicated to doubling the current number of chum salmon within this decade. A lesser number of coho are also reared here. One does not have to be a fisherman to find favour with this scheme.

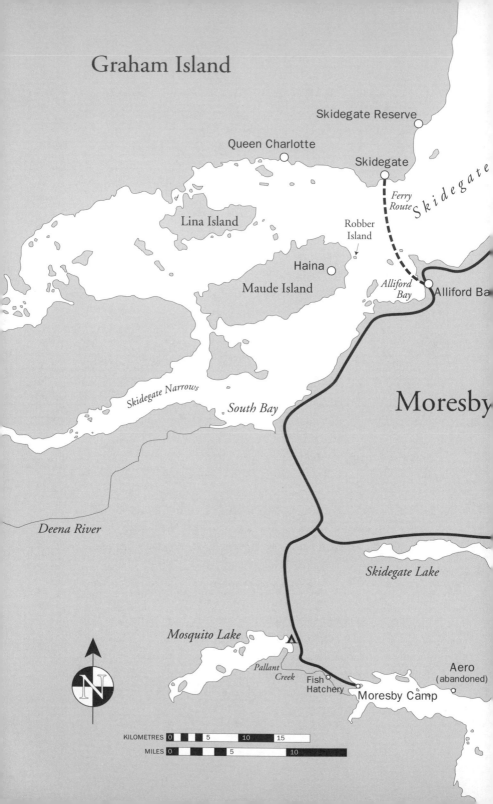

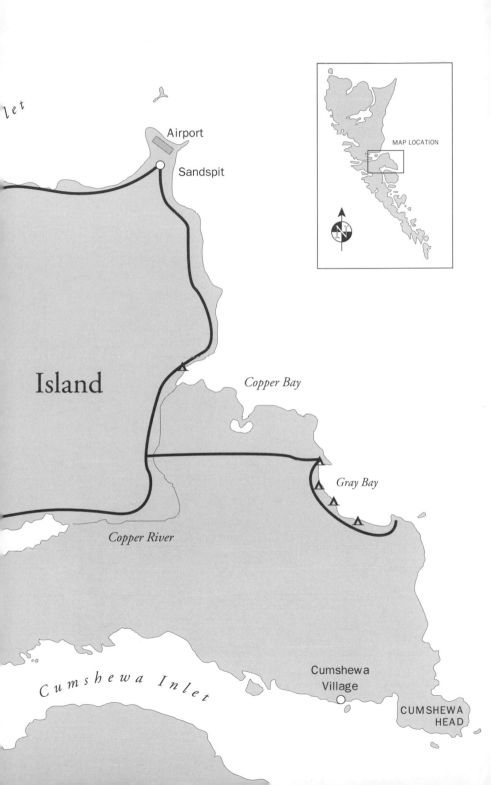

Airport

Sandspit

Island

Copper Bay

Copper River

Gray Bay

Cumshewa Inlet

Cumshewa Village

CUMSHEWA HEAD

MAP LOCATION

N

The road continues onward to abandoned Moresby Camp. Here you will find campsites, toilets, a small-boat float and a gravel boat launching ramp on the shore of Cumshewa Inlet. Mooring buoys are anchored in Gordon Cove, about a kilometre to the south. You are now ready to enjoy excellent fishing, or you can explore the sheltered east coast and its verdant, untenanted islands.

Moresby Camp is as close as you can drive to Gwaii Haanas National Park Reserve/Haida Heritage Site. Its nearest border is some 50 kilometres (30 miles) south, accessible only by air or water. Hiking to the park isn't feasible because of the rugged terrain and jagged shoreline.

If you feel like a good hike, or have a four-wheel-drive vehicle, there is a rough road over a low but steep pass that twists through a narrow valley to Peel Inlet. Here it is possible to launch a boat and enjoy good bottom fishing or explore the many beaches and five west coast inlets surrounding Hibben Island.

When you leave Moresby Camp and return to the Loop, continue through the rolling, logged hills until dropping to near sea level. If you turn west, the road leads to the scenic tidal estuary of the Deena River, where you will find

The *Haida Monarch* passing Balanced Rock, just northeast of Skidegate Reserve, as it enters Skidegate Inlet to load. The *Haida Monarch* is the world's largest self-propelled, self-loading and self-dumping log transport.

good fishing and a large area logged off over many years. The second growth ranges from small trees to some about half-matured. Continuing right, or east, soon brings you to South Bay, TimberWest's log dump, where bulky machines with gaping jaws capable of holding tonnes of valuable logs speed about as skilled operators rapidly sort the logs according to type and use. Often one may see a crew loading as much as 2.5 million board feet of logs aboard massive self-dumping barges for towing to mainland mills.

After you drive eastward a few kilometres, the road splits. The fork to the left is nearly level and follows the shoreline. The one to the right leads over the hills. Both branches lead to Alliford Bay where large concrete slabs remain from the abandoned World War II RCAF seaplane base. From here air patrols were launched westward to help boats maintain a string of eight isolated coast-watch stations. Near Sachs Creek is a shake mill that produces roofing material from blocks of salvaged red cedar.

While waiting for the ferry *Kwuna* or searching for rocks and small fossils, you might see the *Haida Monarch,* the world's largest self-loading, self-dumping, self-propelled log transport, loading up to 3.5 million board feet of timber.

By Boat

Skidegate Inlet to Louise Island The memorandum of understanding signed in 1987 that established the Gwaii Haanas National Park Reserve/Haida Heritage Site assured Sandspit that it would get a small-boat harbour to aid in the transition from an economy based on logging to one dependent on services and tourism. Finally, in late 1994 $10 million was appropriated for construction of the harbour, to commence during the summer of 1995 and to be completed within two years. Because of ecological considerations the harbour was located near Haans Creek, on Sandspit's western edge, instead of conveniently near the airport and shopping centre.

The harbour opened on July 1, 1997, and provides moorage for 80 boats and a cruise ship of not more than 35 metres (115 feet) in length. Electricity and fresh water are available at each moorage. Sanitary tanks can be emptied at a separate float near the shore-level loading pier, which is equipped with a swinging crane that has a capacity of 2,700 kilograms (5,950 pounds) and a hand-powered

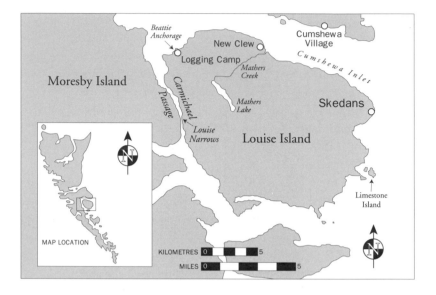

winch. Two nonslip aluminum ramps lead from the floats to the harbourmaster's office and a public telephone. At the east end of the asphalt parking lot an excellent concrete all-tides ramp makes launching and recovery of boats an easy task. This fine harbour should be an excellent base for an expanding sportfishing, tourist and recreation charter boat industry.

In Skidegate Inlet, Prince Rupert is the reference port of your *Canadian Tide and Current Tables*. Refer to Bella Bella when you reach Selwyn Inlet. Sport fishermen heading for the west coast often launch in Alliford Bay at the concrete all-tides ramp where the ferry lands. Avoid any possible conflict with the *Kwuna*'s schedule. A pier and small float located less than a kilometre north are used by water taxis. Just south of the ferry slip is Harbour Air's year-round seaplane base and float. It is especially busy during summer as sport fishermen are flown to and from the fishing lodges. A few local boats are anchored here.

At the east end of Maude Island wave action often uncovers blue or red trade beads in the gravel beach at the abandoned village of Haina, a Native reserve where a school and Methodist church were once maintained. Gnarled apple trees and a solitary totem are all that remain of this nearly overgrown village site. On Maude Island's northeast point there are a few old Haida graves, some criminally desecrated by people removing or breaking the marble stones.

At low tide it is possible to walk across the neck of land to Robber Island and see Chief Gold Harbour's marble gravestone on which some long-forgotten carver misspelled "Chief."

Again ready for sea, having moored for a few days in either Queen Charlotte's boat haven or Sandspit's new small-boat harbour, you will enter Hecate Strait well north of the spit. Skirt the extensive and abrupt shoal north and east of Sandspit, where hull-smashing boulders lurk below the surface, and when you turn south, stay offshore to avoid glacial-deposited rocks until you pass Cumshewa Head.

Kayakers may take advantage of the tidal currents of up to one and three-quarter knots on the north-flowing flood tide. The ebb tide moves south even faster after heavy rains. If going against the tide, you will usually find a weak countercurrent near the shore.

Extensive beds of perennial kelp lie between Gray Point and Cumshewa Head, waiting to clog an engine's cooling system or snare propellers, oars and paddles. Lost or discarded line and fishing nets may be tangled or concealed in kelp, where only your propeller can find it. At high tide, kayakers may ride the quieter water between kelp beds and stony shores.

At Cumshewa Village, an abandoned Haida settlement on the north shore of Cumshewa Inlet, old apple trees suggest early contact with explorers, traders or sea otter hunters. Cracked grey totems stare at large mounds of rock. Do these rocks, placed well back from the beach, cover the remains of victims of smallpox or typhoid? Or are they just rocks that the Haida laboriously cleared from a hard-scrabble garden before planting potatoes?

Along this sheltered east coast, you may see weathered stumps near the shoreline, evidence of hand-logging. Hand-loggers are hard-working people, usually a couple or family who log selectively. Each tree is felled close enough to the water's edge in order to get the log to salt water without the aid of land-travelling power equipment.

Skedans, an abandoned Haida village on the east side of Louise Island, displays the Charlottes' second largest group of standing totems. These sea- and weather-wise Natives selected practical and beautiful sites for their villages. Skedans is typical. The village was built on a wooded neck of land, with crescent beaches to the north and south where heavy dugouts could be launched or landed in almost any weather. Kayakers and small-boat operators usually

find Skedans' south side best for landing or anchoring. Skedans is protected from northwest winds by a high cliff and is surrounded by waters rich with lingcod, halibut and salmon. Submerged rocks abound with abalone, rock scallops and edible mussels.

The totems at Skedans include one with a two-metre (6.5-foot) segment of Doric design, perhaps patterned after a sketch seen in a book owned by an early missionary. The "drums of Skedans" may be heard throbbing from a subterranean source when the northeast seas pound into a small sea cave on the point. A scale model of Skedans (formerly Koona), as it was at its height, is on display in the Royal British Columbia Museum in Victoria. Although uninhabited, this and the Charlottes' other abandoned Native villages are Haida reserves owned by the Natives in Skidegate or Old Massett. *It is unlawful to remove, harm or destroy any part of these old villages.*

Skedans is one of my favourite villages and a popular stop for tourists who,

Junction of old logging roads on Louise Island near Mathers Creek. This road of sawn logs, made for trucks fitted with hard rubber tires, was much like a small railway. This picture was taken in 1955. Today alder trees obscure this road and engulf the 16 old trucks abandoned nearby.

in summer, are guided through the old site by Haida Gwaii Watchmen, an interesting and educational experience. Skedans is easily reached by small craft from Moresby Camp or Sandspit on a day trip that may include stops at Cumshewa Village and New Clew before circling Louise Island and traversing dredged Louise Narrows and exquisite Carmichael Passage. Seals, sea lions, even orcas are likely to be seen on this trip. Captain Chittenden reported 25 houses and 30 carved poles at Skedans in 1884 – and only 12 Natives! At Cumshewa Village he counted 60 Haida, 18 houses and 25 carved poles.

The abandoned Haida village of New Clew is on the Louise Island side of Cumshewa Inlet. Near the village site, on the banks of Mathers Creek (once Church Creek), is a small graveyard with marble stones bearing inscriptions such as, "Kitty Kitsawa, she was a Methodist." What price, these carved markers shipped from Victoria? Did the seller demand a stack of prime pelts as tall as the monument?

Nearby, hidden by alders and a dense growth of prickly young spruce, are the ruined frames of Leyland logging trucks with solid rubber tires. These trucks ran on a two-track trestle road made of logs sawn in half and laid smooth side up, with similar but lighter slabs as guides on the outer edges. Turntables and Y-switches, similar to those used by railways, reversed the trucks' direction or shunted them to branch roads. Weathered sections of this old road may be found leading to Mathers Lake at the head of a large valley, much of it logged more than 65 years ago.

Mathers Creek offers excellent fishing for trout, steelhead and salmon. Take time to enjoy the beauty of this broad valley where the Haida once laboriously chopped great canoes or totems from giant cedars. New roads and branch roads have been built on Louise Island by the logging company based at Beattie Anchorage on the island's northwest shore. One of these roads, along the island's west side, connects to Rockfish Harbour. Buoys provide safe moorage near the booming and sorting grounds. Scheduled and charter flight service from Sandspit is maintained while the camp is operating.

Along Cumshewa Inlet and other coastal bays and inlets, many lower hillsides are covered with uniform stands of dark green second-growth timber that sprung up after the logging that was done 30 to 90 years ago. These logging crews usually lived on float camps, a name derived from the log floats that were rafted to form compact, easily moved camps. Shops, sheds, wash and drying

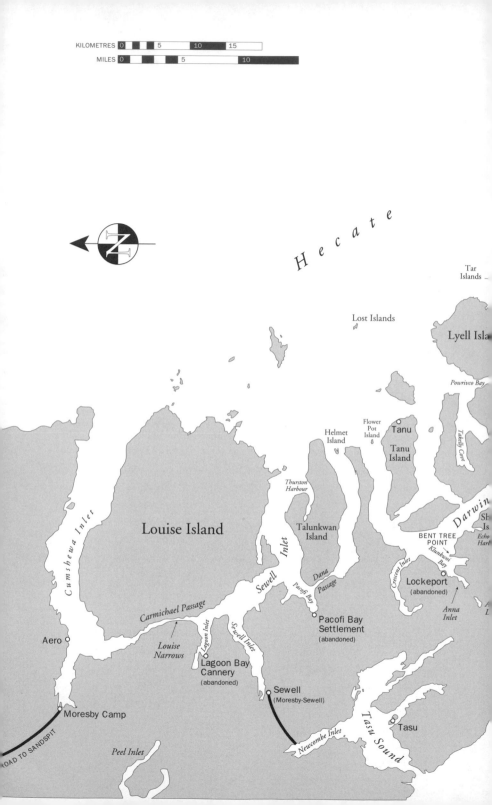

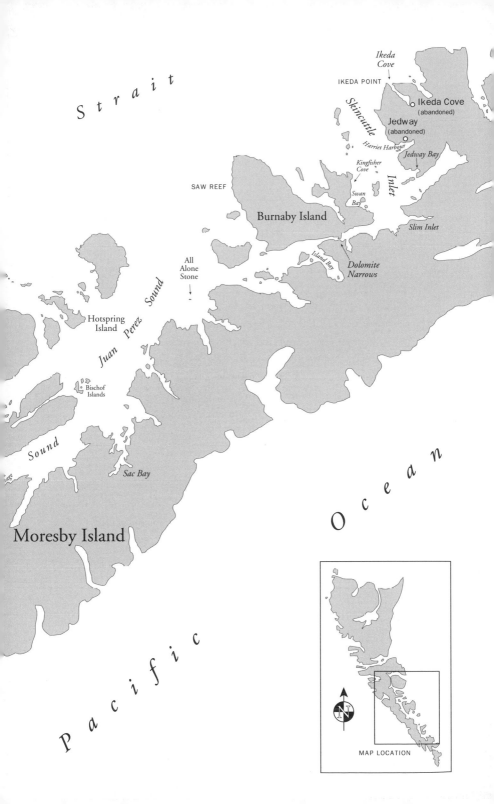

Ikeda Cove

IKEDA POINT

○ Ikeda Cove
(abandoned)

Jedway
(abandoned)

Skincuttle

Harriet Harbour

Jedway Bay

Kingfisher Cove

Inlet

Swan Bay

Slim Inlet

SAW REEF

Burnaby Island

All Alone Stone

Island Bay

Dolomite Narrows

S t r a i t

Hotspring Island

Juan Perez Sound

Bischof Islands

Sound

Sac Bay

Moresby Island

O c e a n

P a c i f i c

N

MAP LOCATION

rooms, bunkhouses and a cookhouse were built or skidded onto these sturdy floats. A tugboat or two and crew boats were tied alongside, within a metre or so of the living quarters. The camp was moored in a sheltered cove near a small stream until the area was logged off. Moving was quickly accomplished with a minimum of disruption and cost. They merely hauled aboard the water hose from the stream, cast off lines to the beach and towed the A-frame and camp to a new location.

Cumshewa Inlet to Skincuttle Inlet Continue westward in Cumshewa Inlet past the remains of a pier at the derelict camp of Aero on Moresby Island, once headquarters for the Charlottes' only railroad logging company. Near the inlet's head or in adjacent Pallant Creek, from August through mid-October, salmon fishermen often catch their limit.

In case you wish to return to Sandspit for supplies, mail or one of your party has to fly home, you can often catch a ride from Moresby Camp, or use your radio-telephone and call a taxi. Moor alongside the small float at the end of the causeway in abandoned Moresby Camp or to one of the buoys in nearby Gordon Cove. Additional facilities are planned for Gordon Cove that include a boat ramp, floats and an upgraded access road. These will make access to Gwaii Haanas National Park Reserve/Haida Heritage Site more convenient for seafarers.

Along Moresby Island's east coast and adjacent islands, derelict buildings or teredo-eaten pilings record sites of former logging camps, canneries or mines. Their trash piles are now treasure troves for bottle collectors. Anchoring in front of such places is a gamble, however, for the bottom is often littered with heavy cables or discarded equipment.

Cruise through scenic and calm Carmichael Passage, a narrow gash between Louise and Moresby islands. The mountains rise abruptly from tree-covered shores and have snowcapped peaks nearly year-round. A kilometre from the southern end of the passage, on the Louise Island side, are a buoy and log float where fresh water may be obtained. Other buoys have been anchored further north. The passage necks into Louise Narrows, a 12-metre-wide (40-foot-wide) dredged channel curving through the forest with leveelike gravel banks close abeam. Catch this at high-water slack for maximum safety. The tidal stream may flow up to three knots.

As the narrows opens, a small bay is sighted to the east. Westward is Lagoon Inlet, where an old cannery was converted into a logging camp and used for a short time before it partially burned. Bricks and pilings from the pier are visible at low tide. Trees have nearly reclaimed this site. The lagoon itself may be entered with a small boat at high-water slack via a short, constricted passage that is subject to tidal rapids and overfalls. Salmon and trout streams drain to the sea through the extensive drying flats at the head, where black bears feed during the spawning season.

Cruising into Sewell Inlet, you will see clearcut hillsides and hear high-powered diesel trucks. At the inlet's head is Sewell, a logging camp of fewer than 20 people and headquarters for the local logging and tree farm operations of Western Forest Products Limited. Floats for small craft and a ramp for amphibian planes are sheltered behind the log dump and booming grounds. A road about 10 kilometres (six miles) long winds from Sewell to Newcombe Inlet in Tasu Sound, located on the west coast of Moresby Island. A telephone is located in the camp office and water can be obtained at the mooring float.

As you enter or leave Sewell, study the surrounding hillsides for examples of tree farming in its various stages. Near the shore is second-growth timber approximately 50 years old; above are trees hand-planted in a checkerboard pattern; farther up are patches of natural seeding, some hand-thinned. Old-growth forests are a mix of live and dead "spire and candelabra" trees.

Pacofi Bay boasts an excessively massive concrete seawall and a mysterious past. Built in 1910 by the son of Count von Alvensleben, the Pacific Coast Fisheries plant (from which the name Pacofi derives) operated for only one year as a cold storage plant. In 1938, while a wrecking crew was preparing the site for new construction, an extensive concrete installation was discovered hidden under the old buildings on the bay's south side. Experts concluded that this might have been intended as a German submarine base. (See *Salmon: Our Heritage*, by Cicely Lyons.) Today the attractive two-story South Moresby Lodge – the only lodge currently in South Moresby – overlooks Pacofi Bay and two small streams where, in late summer, salmon spawn. When operating, the lodge offers both fishing and wilderness experience on either the east or west coast of Moresby Island.

Along the east side of Dana Passage and almost overgrown by young alder trees are the remains of a beached and burned two-story float camp. The tiny

Echo Harbour, often a haven for small boaters, always a place of serenity and beauty where, in the fall, one might see and hear salmon leaping the small falls as they migrate upstream to spawn.

bay usually affords adequate anchorage.

A logging camp operated in Thurston Harbour on Talunkwan Island until 1976, when operations were completed and the camp moved to Powrivco Bay on Lyell Island. The hillsides are once again green. Steep gravel roads, now used by hikers or hunters, spiral into the glowering sky. Sunlight pierces the clouds, spotlighting the hillside, an eagle's nest or the dark inlet where excited salmon leap from the chilly water. Mooring buoys are located at the head of Thurston Harbour.

When you pass Porter Head on Tangil Peninsula, you will enter Gwaii Haanas National Park Reserve/Haida Heritage Site. Hunting is prohibited within the park reserve.

Excellent examples of the multilevel floors typical of large Haida community houses can be seen at Tanu, an abandoned Haida village on the east end of Tanu Island. Tired totems and crumbled longhouses arc around the protected landing beaches. During the summer months, Haida Gwaii Watchmen reside here and generously share their knowledge of this once-happy village.

Abandoned Lockeport sits at the entrance to tiny Anna Inlet in Klunkwoi Bay (Moresby Island). From 1907 to 1928 the fate of this settlement was tied to

prospectors, mining claims, commercial fishermen and canneries. Part of an old cedar shake trail still exists, climbing from the inlet to Anna Lake, a pleasant 20-minute hike. During the late 1960s, and again in 1988, the hills of Swede Peninsula along Anna Inlet were drilled, cored and examined in hopes of making an ore strike. The attempts were just a repetition of an old story – more money going into the holes than coming out. Yacht owners will find sheltered anchorage near the head of Anna Inlet. A good anchorage for small craft is found in Echo Harbour where a small stream tumbles from the surrounding verdant hills that rise steeply to slumbering mountains.

Names on this area of the chart fire the imagination: Bent Tree Point; Crescent Inlet; Helmet, Flower Pot, Lost, Tar, Hotspring and Rainy islands; All Alone Stone; Saw Reef; Kingfisher Cove; Island Bay. Two other names, Powrivco Bay and Takelly Cove (both on Lyell Island), were derived from the Powell River Company, a logging concern, and T. A. Kelly, a colourful pioneer in the history of logging on the island. Until mid-1987 Frank Beban Logging Limited operated a modern camp in Powrivco Bay. The generous services once given are greatly missed.

In 1955 my family and I stopped at an old gold mine on the northeast side of Shuttle Island, located in the middle of Darwin Sound. On that particular day the three partners made the big decision to quit wasting time and money. After demonstrating their method of operation, they presented our bug-eyed 11- and 12-year-old sons with the day's gleanings – a few tiny flecks of dust, nearly a nickel's worth, placed, appropriately, in an aspirin bottle. The open shaft of that abandoned mine is easily found near a tumbled shack surrounded in summer by tall, bell-shaped foxglove.

Darwin Sound to Kunghit Island Fresh water, clear and cold, is available from a hose secured to a deep-water float located in a small notch in Moresby Island and usually referred to as the Water Hole. It is west of Shuttle Island and entered from Hoya Passage. Mooring buoys are also located here.

Opposite the Water Hole is a small bay in Shuttle Island that power cruisers can enter – passing over a rock ledge – only at high tide. This gunk hole offers a secure anchorage, distinctive scenery above and under the water and a central spot for ranging out in a small boat to numerous beaches and seldom-visited tiny coves.

Narrow Kostan Inlet is best entered at high-water slack due to a tidal stream that can run at two to four knots, flattening kelp growing in the shallow entrance to this sheltered anchorage. A remarkable variety of colourful marine life and plants are found here, exceeded only by that found in Dolomite Narrows. Waterfowl, deer and bears are frequently spotted on or near the lush flats at the inlet's head.

Exploring the numerous bays, inlets and islands in and around Juan Perez Sound might easily fill many happy days. With good charts and an alert bow lookout, you can navigate this fascinating area of rocks, islets, beaches and seabirds where clear streams leap from rolling, tree-covered hillsides. With a tidal stream of two to three knots, traversing five-kilometre-long (three-mile-long) Beresford Inlet – so narrow you may have difficulty turning your vessel around – is a unique experience. To the east, Sedgwick Bay is only a short hike across low land.

The Bischof Islands, a serene group of one large and several small wooded islands and many drying rocks, form a broken ring around a small, hidden anchorage. A fine camping spot. Scores of auklets and murrelets feed here, surfacing with tiny fish dangling from their beaks before diving for more. Gulls ride drifting logs, preening and whiling away the hours until the outgoing tide uncovers their next meal. Cormorants dive for small fish, and you may be lucky enough to see a humpback whale cavorting in the sound.

Continuing east past Sedgwick Bay and Faraday Island, you might want to enter Gogit Passage and head north past dark Agglomerate Island. Shortly after you leave the Tar Islands astern to starboard, you will spot Gogit Point on the port bow. Northwest of this blunt point is a shoaling indention in Lyell Island called Windy Bay. The extensive surrounding valley, drained by a fine salmon stream, is heavy with great old-growth trees, primarily spruce. Recently a colourfully painted Haida longhouse was constructed at the forest's edge, overlooking the bay. In the summer Haida Gwaii Watchmen welcome visitors. Well offshore is Skaga Island, formed of twisted, multicoloured rock; its baroque beauty is best appreciated from a helicopter. A single tree has found sustenance here.

An added treat while cruising Moresby Island's intriguing east coast is the pleasure of catching enough salmon, lingcod, halibut or red snapper for at least one meal a day. If you are just lazing along, a lure behind a flasher and weight

tossed over the stern and tied to a strong length of monofilament should do the trick. A bungee cord and little bell can be rigged so you don't have to keep checking the line, but that is a lazy person's idea of fishing for food.

Juan Perez Sound can be uncomfortably rough during a southerly or easterly storm, but surrounding bays and inlets afford shelter for your craft and many beaches for your crew to hike. These beaches accumulate less interesting ocean drift than outer shores due to their restricted entrances.

A soak at Hotspring Island is a must! The tub there used to be of Japanese design with heavy wooden planks and ample depth. But enjoy the present. Ease into one of the open, hillside pools for a leisurely and relaxing bath while you listen to a happy song sparrow and enjoy an unimpeded view across Juan Perez Sound to the snowy peaks of the San Cristoval Range. There are also conventional metal tubs placed side by side, with an excellent view of the hot springs and the sea. Another tub is modestly covered by a small shack of cedar and plastic. Mix the hot and warm running water and indulge in a steaming, slightly sulphurous, soothing bath without the annoyance of gradually cooling water, or enjoy the family-size hillside pool. During the fishing season you may have to wait your turn while tired commercial fishermen soak themselves. Wind and tide may abruptly change the sea conditions at the insecure anchorage off the southwest side of Hotspring Island. In summer Haida Gwaii Watchmen are in residence and can advise you concerning anchoring, camping and fishing, as well as answer questions you may have concerning the islands. Mooring buoys are found across Ramsay Passage at Ramsay Island.

There are more enticing little sandy beaches, bays and inlets along Moresby Island's east coast than you will have time to explore, even with a month's vacation. If it can't be a continuing project, you should settle for touching the highlights of these seductive islands. In any case, a keen-eyed lookout is a must as you nose into some of these seldom-explored coves and rock-encumbered passages where a few uncharted hazards lurk.

After a rain, Sac Bay's dark waters – on the southwest side of rocky and baroque De la Beche Inlet – are brightened by mounds of foam riding seaward like miniature icebergs from two chattering waterfalls. The shore is rimmed with black lichen-covered rocks and decorated with golden rockweed. On windless days the still water mirrors the steep hillside, surrounding your boat with trees that appear to be standing on their delicate tops. This is the favoured

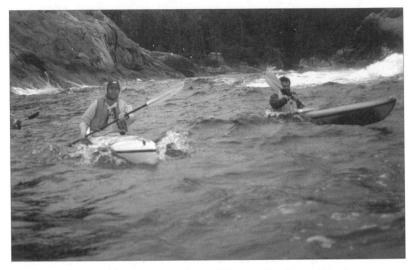

Some rough water for kayakers off Moresby Island's west coast.

place to commence a hike along a cascading stream, past a forest-encompassed lake and across the low mountains to Puffin Cove.

A float camp is maintained in Crescent Inlet from June through September by Moresby Explorers Limited. Kayakers frequently start their trips here. Others may set up a base and overnight here while enjoying day excursions.

High tide and calm water is an invitation to creep into rocky, tree-enveloped Skittagetan Lagoon just to enjoy its solitary splendour. Haswell Bay, Hutton, Marshall and Matheson inlets all deserve an inspection if time allows; if not, check any one of them, for all are similar: relatively narrow with rocks or shoals. The same applies to the passage between Marco and Moresby islands.

Anglers trolling along the east side of Juan Perez Sound from De la Beche Inlet to Huxley Island should enjoy good fishing during the summer while unseen hordes of coho feed and grow, preparing to spawn in the multitude of streams pouring into the sound. Betty and I have found a greater number of adult and immature bald eagles in Juan Perez Sound during late summer than in any similar area. Salmon streams, no doubt, provide the attraction.

Buoys in Section Cove offer quick and secure moorage for the night, although your craft may roll a bit with the change of the tide. Floating, rectangular

log enclosures supporting a net bag may be moored here. In spring these are filled with fresh-picked kelp fronds and then thousands of seine-netted, roe-filled herring are released in these enclosures to spawn on the kelp. The egg-covered fronds are then harvested for drying or salting before being shipped to lucrative markets in Japan.

Kat Island offers a short sand beach and plentiful driftwood to kayakers and those with small boats seeking a picturesque and restful campground. Eagles may watch from a nearby nest and ever-curious seals will pop up to check you out. No doubt you will enjoy some summer days so warm and still that sun-dried sand floats on the rising tide and clamshell halves are gently lifted off the beach to drift away like tiny white coracles.

Island Bay is aptly named. It is also littered with rocks seen and unseen, so proceed into Dolomite Narrows on the last half of the rising tide when most of the dangers of the short but tortuous channel can be seen. This is a small area rich with intertidal marine life that will keep you busy with the camera

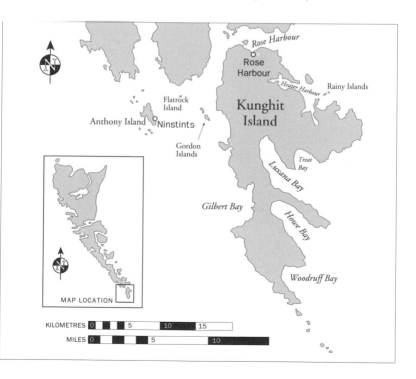

recording a great variety of colourful subjects. This may be enjoyed from your craft, but not by wading in or walking through.

Interesting, and usually abandoned, log or shake-covered cabins and lean-tos are still found along the serene shores of Dolomite Narrows, Swan Bay and other isolated streams or beaches on Burnaby Island's south side. These were built by young men and women trying to get away from it all nearly 30 years ago. Masses of white shells and a rusting boiler on the north shore of Bag Harbour tell of a clam cannery abandoned by its Japanese owners before World War I. This is a good spot to anchor and then cast from boat or shore for salmon.

More than 130 years ago Francis Poole, a civil engineer, and his crew drilled and prospected for copper in Skincuttle Inlet – without ever making a strike of commercial value. The five Copper Islands have some attractive shores for the beachcomber. Anyone tramping around Pelican or Poole points should be rewarded by finding one of Poole's hand-drilled adits. East Copper Island is an ecological reserve.

Jedway, in Harriet Harbour, was founded early in the 1900s and flourished as a centre for prospectors until World War I. In 1961 it was resurrected as an iron-mining town of more than 200 people. Iron concentrate was shipped from Jedway to Japan until mid-1968. The town was again laid to rest, the buildings razed or moved to Sandspit and Queen Charlotte and an effort made to cover the scars of open-pit mining. Today the forest is rapidly reclaiming the site and creeping over the washed-out roads.

The harbour here is subject to heavy squalls funnelling out of the valley during strong southerly gales. At such times shelter can be found in nearby Jedway Bay, where there is usually a water hose. Remains of a Japanese abalone cannery, operated prior to World War I, and the flattened ruins of a cannery closed during the Great Depression are at the east side of the bay's entrance.

Waters around the Charlottes are uncommonly clear, increasing the pleasure and success of scuba divers or snorkel enthusiasts. Skincuttle Inlet encompasses over two dozen islands and islets with a variety of beaches. Its shoal waters, rich with spiny sea urchins, beche-de-mer and rock scallops, make this an excellent place to enjoy underwater sports. Northeast of the East Copper Island Ecological Reserve you will also find the 220-tonne *Lark,* wrecked in July 1786.

A wireless station was constructed on Ikeda Point in 1909 and operated until 1920. The roofless blue-green stone structure, once housing a crew of radio operators, is hidden within a forest more than three-quarters of a century old. The walls may be found by climbing the rocks on the point's south side and heading north.

Rusted narrow-gauge tracks, some dangling like dead vines, lead from the shores of Ikeda Cove to an abandoned copper mine. In 1907 a Japanese fisherman-prospector opened the islands' first profitable mine, shipping the ore to his home country. The old sternwheeler *Dawson* was converted into a bunkhouse and moved here onto a grid of timbers and pilings, where its charred keel remains. Hikers may follow the old rail line through thick second-growth timber and blowdowns or climb uphill from the cove's head, ultimately striking a weathered gravel road twisting down from the open-pit mine to abandoned Jedway. Amid the forest on the bay's south side are four marble stones engraved in Japanese with the names of men who died at the mine.

The Rankine Islands, an ecological reserve, are fringed with rocks and extensive kelp beds that attract large numbers and varied species of seabirds. Kayakers and those enjoying the versatility of inflatable boats will appreciate

The author with the lower jawbone of a 15-metre (50-foot) sperm whale, the vertebra of a blue whale and a large Japanese glass float, all beachcombed along Moresby Island's west coast.

the easy landing and pleasant camping under the spreading branches of forested Benjamin Point. A small upswept gravel beach on the north side is protected by rocks and reef to the east. Kelp muffles its mouth. The Haida village of Kaidju was once here, although little evidence remains. Black bears are often seen in this vicinity, so be wary. So far no one has been attacked, but as both the number of bears and people increase, so do the chances of an unfortunate encounter.

The fast-flowing tidal streams – up to five knots – of Houston Stewart Channel separate Moresby and Kunghit islands while connecting Hecate Strait and the North Pacific. This is the usual and calmest route for boaters traversing between Moresby's east and west coasts. Kayakers will find many attractive places to haul out and camp. Raspberry Cove, across from Rose Harbour, is one of the most favoured spots.

Beachcombers will spend many happy hours investigating secluded beaches,

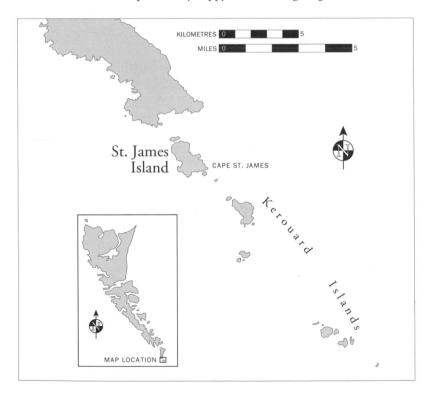

especially low, rocky Ross Island where sea drift is abandoned by hurrying tidal water. A variety of waterfowl are attracted to the grass-covered flats at the head of Rose Inlet. A creek debouching from the mountains to the west provides spawning beds for salmon that in turn lure hungry bears. Lowland to the east affords hikers access to the South Cove of Carpenter Bay, which you will probably want to avoid with your vessel due to its many scattered drying and sunken rocks.

Kunghit Island and St. James Island From 1909 until World War II Rose Harbour (named for a British politician) was a bustling whaling station employing 150 men. Wooden tanks rich with the smell of whale oil, tumbled buildings and the remains of a pier once stood beside this all-weather bay. In 1978 a small group of young island residents purchased the land and built imaginative homes amid the station's brick-and-metal ruins. Bits of whalebone and teeth and broken harpoon heads lie along the shoreline.

This serene clearing is brightened in springtime by tall daffodils, and in midsummer by head-high stalks of brilliant foxglove. Bed-and-breakfast accommodation and boat transportation are available here at the only private commercial facilities within the park reserve. Helicopters and floatplanes land with tourists, and charter vessels frequently moor at the government buoys.

Anchorage may be obtained at the west end of Heater Harbour, located on the northeast side of Kunghit Island, but you will be more secure in Rose Harbour. Kunghit's southeastern side features a series of four bays: Treat, Luxana, Howe and Woodruff, each with smooth sand beaches lapped by small waves and covered with accumulations of interesting drift. While attractive to visit, these open bays offer scant shelter, and the nearly constant southeast swell makes them uncomfortable overnight anchorages.

Exposed and rocky-sided Gilbert Bay gouges the southwest edge of Kunghit Island. If the sea is quiet, you can anchor for a few hours in the kilometre-wide cove at the open bay's northeast corner and land through a low surf. Here bright yellow sand slopes gently upward from turquoise waters, becoming rolling dunes covered with waving grass that retreats into the stunted, wind-bent forest. Driftwood decorates the storm-delineated high-tide line. Japanese glass balls and other drift treasures are tossed ashore by rows of breaking waves. Deer wander along the beach nosing through the kelp or stand quietly while munching choice

The author among the totem poles at abandoned Ninstints village. How much longer can these magnificent remnants of Haida greatness resist the ravages of time and the elements? In 1955 there were more than three dozen poles rimming the gravel beach of this hauntingly beautiful and secluded site. Now hardly a dozen still stand.

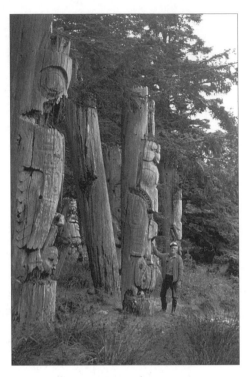

pieces. This portion of the bay is unusually attractive and may entice you to relax for a day or two – providing your kayak or inflatable boat is light enough to carry well above the high tide.

St. James Island was the location of the manned Cape St. James lighthouse and weather-reporting station from 1913 until September 1992, when most of the buildings and access walkways were demolished and an automated light and weather-reporting station were installed. During the last two years of World War II, the RCAF posted some 60 men here to operate a radar station. As late as 1955, families were stationed here to maintain the light and meteorological station. Riotous winds made it necessary to lash the unprotected Quonset homes to the rock with steel cables.

For anyone landing on this inhospitable rock, it is a long climb up the steep and grassy hillside to the helicopter pad and from there up to the top. However, the view is worth every step. From here the verdant, round-topped Kerouard Islands look like a string of elephants belly-deep in swirling water.

These islands, with vertical cliffs on all sides, are breeding places for countless seabirds. Sea lions haul out and pup on some of the lower rocks on the west side. The ever-active waters here are rich with food, attracting an abundance of fish, seals, sea lions and a wide variety of seabirds.

Often a comfortable anchorage can be found midpoint on the eastern side of the wooded and drift-catching Gordon Islands. Sandy beaches and tidal pools in the centre of this group are filled with marine life and a variety of birds, inducement enough for photographers and beachcombers.

The appropriately named Flatrock Island is 21 metres (69 feet) high and about midway between the Gordon Islands and Cape Fanny, the southern extremity of Moresby Island. In spring and summer this barren island interests birders because of the innumerable seabirds found here, including the horned puffin with its massive bright red-and-yellow bill. A great majority of the puffins found in the Charlottes are the tufted species. Fewer varieties of seabirds frequent this exposed rock during fall and winter.

Anthony Island to Gowgaia Bay Unlike the gradually shoaling east coast, the west coast of Moresby Island is deep and its shore steep, often with nearly vertical cliffs, and the 100-fathom curve lies little more than just over a kilometre offshore. This is *not* a coast for hiking.

Remote and unsheltered from the rampages of the North Pacific, bird-foot-shaped Anthony Island (Skun'gwaii) was the southwesternmost home of the Kunghit Haida until abandoned shortly after 1884. That year Newton Chittenden found only 30 inhabitants, 20 houses, 25 carved poles and 20 mortuary poles in this isolated village on a small east-facing bay. Today fewer than half of those poles remain. This is Ninstints, best preserved and loveliest of old Haida villages.

The nervous ocean breaks on the rocky shore of this low, secluded 140-hectare (346-acre) island. At high tide small boats can enter the stubby channel through swaying kelp and land on a short, curved beach. At low tide a canoe launching path, cleared perhaps two or three centuries ago, is still visible and usable, slippery with seaweed. Great dugouts once struck out from here as the Haida went to trade or fight with the crews of sailing ships, or to paddle across Hecate Strait and trade or battle with mainland Natives.

Sections of tumbled and decaying longhouses that are sheltered by second-

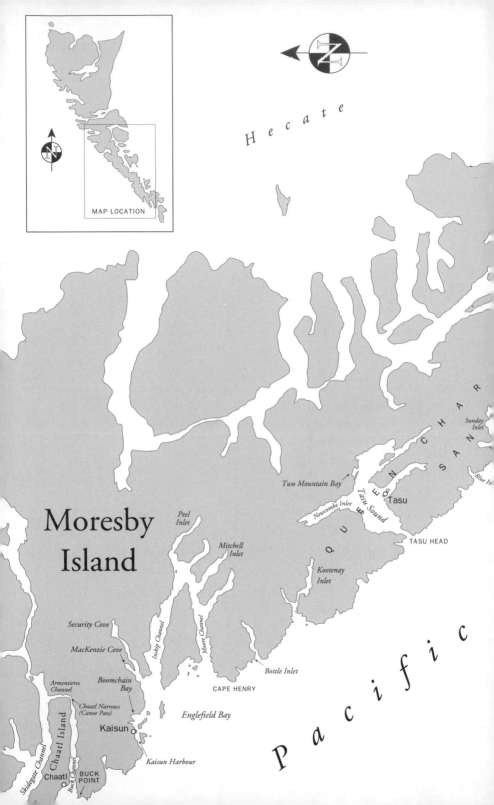

MAP LOCATION

Hecate

N
Z

N

Moresby
Island

*Peel
Inlet*

*Mitchell
Inlet*

Two Mountain Bay

Newcombe Inlet

Tasu Sound

Tasu

Q
U
E
E
N

C
H
A
R

S
A
N

*Sunday
Inlet*

Blue H

TASU HEAD

*Kootenay
Inlet*

Security Cove

MacKenzie Cove

Inskip Channel

Moore Channel

Bottle Inlet

*Armentieres
Channel*

*Boomchain
Bay*

CAPE HENRY

*Chaatl Narrows
(Canoe Pass)*

Kaisun

Englefield Bay

Chaatl Island

Chaatl

Kaisun Harbour

BUCK
POINT

Buck Channel

Skidegate Channel

Pacific

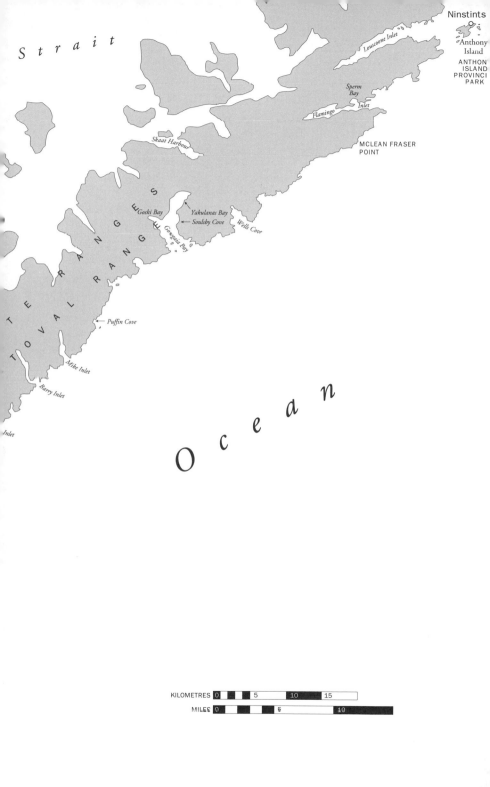

Ninstints

Anthony
Island

ANTHON
ISLAND
PROVINCI
PARK

Louscoone Inlet

*Sperm
Bay*

Flamingo *Inlet*

MCLEAN FRASER
POINT

Skaat Harbour

S t r a i t

Goski Bay *Yakulanas Bay*
← *Soulsby Cove*
Georgia Bay *Wells Cove*

R A N G E S

T O V A L R A N G E S

T E

← *Puffin Cove*

Mike Inlet

Barry Inlet

Inlet

O c e a n

KILOMETRES 0 5 10 15
MILES 0 6 10

growth trees still bear the scalloped cuts of an adz – perhaps an adz acquired in exchange for sea otter pelts during the voyage of Captain Dixon of the *Queen Charlotte*. Six grotesque, blackened poles record a major fire that occurred shortly before the dwindling population forced the survivors to move into Skidegate Mission.

Recently numerous trees have been removed, opening a view to the remaining poles and longhouse sites in the village clearing. Brush and grass have been cleared, lead foil placed in the cavities of five mortuary poles to slow down decay, some leaning poles straightened or braced and fallen poles raised above the damp ground. Although such care will not preserve these weathered poles, it will extend their existence. Gravel walkways lead you to the varied poles. A small cabin nestles among the trees north of the village, and in season a Haida park warden is in residence to guide and tell you about this isolated and hauntingly memorable village.

Today living here would be easier, for while fish and bear are still plentiful, blacktail deer now also abound and wood for campfires covers the upper reaches of any beach. Nearly all the driftwood found on the shores today results from logging.

In 1958 Anthony Island was declared a provincial park so all could see the world's finest collection of standing Haida poles in the village of their origin. Later it was made an ecological reserve and, in November 1981, the island received worldwide recognition when it was added to UNESCO's prestigious list of World Heritage Sites. Boat tours to this once self-supporting island may be arranged in Sandspit or Queen Charlotte. Tourist-chartered helicopters are not permitted to land on Anthony Island.

Louscoone Inlet (a mooring buoy is located in a sheltered notch less than halfway along the east side) and Flamingo Inlet lure the beachcomber. These long, fjordlike waterways are natural catchalls for any drift carried on the Pacific and, in season, offer good salmon fishing. Anvil Cove and Short Inlet are always worth investigating for glass fishing floats. As you head up the west coast, Sperm Bay in Flamingo Inlet is the last reasonable anchorage before reaching Gowgaia Bay. Kayakers have more options.

If the ocean is in a quiet mood, explorers using kayaks, inflatable boats or a shallow-draft craft with shore boats should enjoy hours of beachcombing or photographing the many and varied beaches from Louscoone Point to Sperm

Bay. Cape Freeman, one of my favourites, is often a nasty region of leaping water, flying spume and bashing breakers, but when it is calm…. The wooded cape projects westward as a barbed, drift-catching hook. It is bordered on the south by a ragged series of massive, sea-worn black rocks above and below the surface. There are two or three openings into quiet water where kelp grows, seals play and beachcombing opportunities abound. Birds of all kinds revel in these isolated, food-rich waters, including the rarely seen sandhill crane. Days spent here are too short. Anchoring overnight is not recommended. Kayakers camping overnight may be trapped for a day or more by rough seas.

On any of the island's three coasts, but particularly along the west side, sperm, grey and humpback whales can be sighted, spouting as they cruise along the outer rocks and reefs searching for food or just passing during migration. You might even catch one of those rare moments when, in play or courtship, the great mammals leap clear of the sea, then fall with a resounding crash and flying spray. A waterproof camera is a great asset in the Charlottes whether used in the rain, spray or under water to snatch some rare shots.

A pod of orcas might come whooshing into an inlet at 40 kilometres (25 miles) per hour looking for a meal. At such moments seals will haul themselves out onto the nearest rock, allowing the visitor to approach them quite closely.

A tiny but unprotected notch where a small boat can be landed for camping or beachcombing on Moresby Island's west coast. The sea conditions can change overnight, so be prepared to wait for quiet seas.

They are willing to gamble on your intentions, for they know instinctively the deadly design of the hungry killer whales. Orcas (relatives of the dolphin) weigh from three to 10 tonnes and are easily identified by their erect triangular dorsal fin which, on a nine-metre (30-foot) male, can be as high as two metres (seven feet). At other times 12 to 300 Dall porpoises, up to 1.8 metres (six feet) long and weighing 112 kilograms (250 pounds), may suddenly appear alongside your boat, cavorting and splashing as they cross and recross the bow or glide under the keel until they tire of the game and disappear at a speed of at least 12 knots.

Bones and carcasses of whales and porpoises are occasionally found along the Charlottes' shores. In 1971 Betty claimed and skeletonized a 12-metre (40-foot) grey whale for educational use and has, in addition, sent skulls of the rare Stejneger and Cuvier beaked whales to the Royal British Columbia Museum in Victoria. Few beachcombers carry their avocation to this extreme.

On those days when the ocean is calm, you may sight Japanese glass net floats and bottles – even some carrying a message written in a foreign language. An angler's dip net is handy for scooping these treasures. Sometimes one encounters long, sinuous paths of drift – gathered by the wind and tidal current – containing kelp, fishnet and line, chunks of wood, jellyfish, bottles and balls of glass or plastic.

If you are along the coast during the commercial halibut season, you might see a black-footed albatross smoothly gliding only centimetres above the rolling sea on wings that can span more than two metres (seven feet). These largest of seabirds are less graceful when they alight. With wings spread wide and feet braced forward like water skis, they land to feed on or quarrel over fish or squid. Becoming airborne when the wind is light requires a lengthy, splashing run and much flapping of elongated wings. These are the awkward "goony" birds of Midway Island and French Frigate Shoals. Here you might also see the albatross's cousin, the sooty shearwater, about one-fourth as large. They, and screaming gulls, are also searching for red snappers or other fish discarded by the halibuter.

The southern end of Moresby Island is low and densely wooded. Headlands and shores of massive dark rock are routinely devoid of vegetation to 30 metres (100 feet) or more above sea level because of brutal, often sudden Pacific storms that are sometimes churned up by winds exceeding 100 knots.

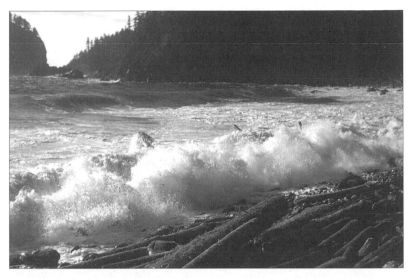

The outer beach of exquisite Puffin Cove, where the Careys lived for many years.

Our experience has been that March and October are the fiercest months, but any month can produce a sudden storm of 60 knots or more. Seabirds, fish, shellfish and unusual debris are found on the shores after these once- or twice-a-year events.

Late in October 1977 Betty and I witnessed one of the most savage and destructive of these storms. It commenced in the early forenoon. By noon the seas, driven by 75-knot winds, were breaking wildly across the entrance to Puffin Cove and crashing onto the inner beach. The winds continued to increase and the combers began to climb up and over the outer rocks, something we had never seen before. Gusts swept water up from the lagoon and cast it about until I thought our cabin was inside a car wash.

Just before dusk, which came early, I saw what I would never have believed could happen. I thought I was watching a freak or rogue wave (I had been hit by one of those years before while taking a tanker across the Gulf of Alaska one winter; it momentarily stopped the ship). I watched until I saw the wave again, then called Betty. The seas were striking one of the vertical outer rocks, racing up and over it, then continuing up another 30 metres (100 feet) – and that rock was 45 metres (150 feet) high! Those weren't rogues that day, just routine waves.

The wind continued to blow at a steady 125 knots. The ebb tide couldn't

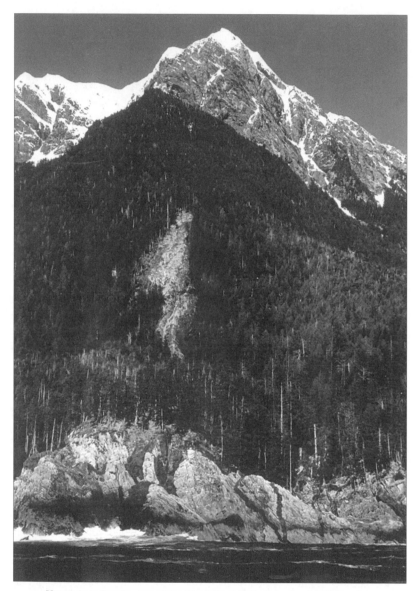

Mount de la Touche, one of the Charlottes' highest peaks at 1,123 metres
(3,700 feet), rises midway between Tasu Sound and Sunday Inlet about one kilometre
from the open sea. This is a typical winter scene, light snow on the peaks while
the lowlands are free of snow. Note the scar of a landslide in the middle and the
intrusion of black volcanic rock into the granite at the shoreline.

escape the coast and remained about a metre higher than normal. By moonlight we watched those horrendous combers spill over the high rock all night.

Six days later the North Pacific calmed enough for us to head out for Tasu. The ocean was covered with driftwood of all sizes and shapes, plus something new – storm-shredded wood chips. Bays were littered with floating logs, while other logs had been hurled into the forest. Glass balls? None. And the plastic floats we usually encountered after a storm must have been pulverized. Abalone, mussels and barnacles had been ripped from exposed rocks. Bottom fish and eels had been lifted from the ocean floor and hurled onto the shore.

Be alert for the tide rips that frequently occur off McLean Fraser Point, especially at the change of the tide or when wind and tide are opposed. Isolated rocks lurk within a kilometre of shore. There are few beaches between Nagas Point and Wells Cove that can be approached with safety. Again, inflatable boaters or kayakers have an advantage here when seas are reasonably calm, because they may explore tiny shores reached through leads wending among sea-sculpted rocks. About two kilometres (1.2 miles) south of Wells Cove is an unnamed bay, a large cave where Natives once lived, beaches clutching ocean drift, a hidden anchorage and the tumbling but easily missed stream from Upper Victoria Lake.

Unsurveyed Wells Cove offers a wide assortment of beaches, sculptured rocks, crashing breakers, gentle tidal streams and a variety of seashells. Perhaps an inquisitive deer, a sleek black bear, an imperious bald eagle or a playful seal will pose against these backgrounds. When the tide is near high it is possible to enter the shallow river at the bay's head and pull a kayak or small boat onto the golden sand before camping for a day or so.

When the big rollers come rushing in, Gowgaia Bay (often called Big Bay) may appear a fearsome mass of breaking seas and jagged reefs. Twice I have seen it so wild that I thought it wiser to stay offshore and try for a more hospitable entrance. However, it has been well surveyed and has a wide, deep entrance. Within are many kilometres of beaches as well as anchorages in Yakulanas Bay, Goski Bay and Soulsby Cove. But be cautious: the wind can veer abruptly or pounce in violent gusts. I have seen winds strike a hillside and ricochet 180 degrees, the storm raging overhead moving in one direction, the surface winds in the opposite direction.

Hikers might decide to investigate the wooded lowlands between Yakulanas

Bay and Skaat Harbour on the east coast. Or they can search for the remains of a World War II coast-watch cabin and radio shack near the south side of Gowgaia's entrance, where five men watched for Japanese warships. This is another lovely camping spot. A little more than a kilometre to the east is a long lake wearing a necklace of yellow sand that disappears under a dense growth of wind-stunted trees. The lake can be entered at high tide with a skiff after crossing a wide tidal shelf.

Gowgaia Bay to Tasu Tasu Sound and five of the six inlets between Gowgaia Bay and Englefield Bay have narrow entrances that are sometimes difficult to see. All are surrounded by steep mountains that are streaked with wispy falls after a rain. Throughout the islands, and especially on the craggy slopes of the west coast, a thin layer of soil nurtures an ever-growing weight of trees and shrubs. After a time of extended rainfall or a jolting earthquake, landslides occur, leaving great triangular scars and a jumble of broken trees at the water's edge.

Just north of Gowgaia Bay are two unnamed indentations. The first is deep and has stony shores; the second is shallow with two attractive sand beaches ideal for beachcombing (one is especially enticing as a camp for kayakers). Due to possible rapid and unexpected changes in the weather, neither of the two indentations are safe for overnight anchoring.

About 10 kilometres (six miles) north of Gowgaia Bay is Puffin Cove, sheltered on the northwest side by 149-metre (490-foot) Puffin Rock, where tufted puffins nest. A short, narrow, rock-strewn entrance leads into the sandy lagoon. With caution, this is accessible to shallow-draft boats near high tide. For years this was our delightful and lovely home where Betty and I enjoyed the varied scenery, bird and animal life and weather of every month. A small stream flows through the lagoon during all seasons, and at low tide it is often less than knee-deep. A coarse-sand beach suitable for camping is located on the west side near the entrance. It is possible to hike across the mountains from Puffin Cove to Sac Bay in De la Beche Inlet.

High, bare peaks surround Mike, Barry and Pocket inlets, where small streams tumble from hillsides wooded with wind-whipped spruce or cedar and deformed, shrub-size trees. All attract a variety of bird life and are home to deer and bears. Usually these inlets are adequate summer anchorages, but when

southeast gales blow, they are subject to heavy squalls or williwaws – sudden, violent gusts tumbling down to the sea from coastal mountains.

At these times winds tumble down the steep hills, striking from all points, whipping up the sea and swirling water high into the air, a severe test for your ground tackle and good reason for having that second or third heavy anchor plus extra line or chain. Find a notch alongside a vertical cliff and moor fore and aft to projecting trees or rocks, laying a kedge anchor to seaward and using the skiff as a fender on the shore side. This is not my favourite method of mooring, but it is effective and allows you to get some rest until the storm blows itself out in four to 36 hours.

During good weather, anchoring on the delta created by a stream is usually okay, but if an offshore wind whips up, your anchor may drag, undetected, through the soft mud to an abrupt drop-off and, before you know it, you are quietly underway.

A natural landslide west of Yakoun Lake – a typical event in the Charlottes.

North of Pocket Inlet sea-sculpted limestone spires tower out of the sea. Behind a group of these photogenic rocks is Kwoon Cove, an inviting sand beach where rolling surf appears to tumble lazily before running up the shore. Study it for a few minutes prior to making a landing; you might avoid a dunking this way. Landing on the steep rocks to seaward of the surf line is often feasible. It is possible to land and depart without even getting splashed (a trick that we have often found safer as well as drier).

At the head of Sunday Inlet is a well-protected anchorage sheltered by the high, treeless peaks of the San Cristoval Range. These peaks are often covered until mid-September with glistening snow that melts just in time to receive a new coat in October or November. Deer, bears, otters and many waterfowl claim domain in the quiet inlet. On a north-side gravel beach, behind a tree-covered islet, stands a waist-high boulder with a petroglyph face, which is easier to see if the rock is wet.

Three kilometres (two miles) north of Sunday Inlet an open cove and short, narrow, rock-encumbered slot open into a leaf-shaped pocket named Blue Heron Bay. To the east, a clear mountain stream drops in a series of falls from a lake ringed with water lilies. Kayakers may find shelter and camping space here. Boaters should be alert for and steer clear of rocks at and just inside the short and narrow entrance, best accomplished by hugging the south side.

A remarkable view of the bay, ocean, lake and mountain peaks is gained by climbing the shelved gorge to its 150-metre-high (500-foot-high) summit. Bonsai-like trees, less than knee-high, wrest a tenuous existence from fissures in the eroded granite, while tiny wildflowers add specks of colour. Deer that have never seen a human being move nonchalantly out of one's path. Many sea lions often haul out for extended naps on wave-splashed rocks midway between Blue Heron Bay and Tasu Head.

You are leaving Gwaii Haanas National Park Reserve/Haida Heritage Site just before rounding Tasu Head to enter Tasu Sound. Three inlets and as many bays are hidden within Tasu Sound. Numerous gravel-bottomed streams debouching into the sound provide spawning beds for four species of salmon. They also abound with pools of hungry Dolly Varden and steelhead trout. Sheltered anchorage can be found in Two Mountain Bay, once site of a small fish saltery and boat works. Fist-size fossils are sometimes discovered in the slatelike rock along the shore.

The company-owned mining town of Tasu closed in October 1983, and a watchman remained until early 1991. Four once-attractive houses and a metal shed are the only structures that remain. Tasu's reason for being was an open-pit mine. Since its opening in 1965, the mine produced approximately one million tonnes of high-grade iron and copper concentrate annually for export, primarily to Japan. In mid-1977 the operation shifted to underground mining. However, the facilities of this modern town, once home to some 400 miners and their families, are no longer available. The economic contribution of the mine is greatly missed, for half of the Charlottes' tax revenue originated here. Trees and seeded grass are rapidly reclaiming the mine and town site.

Tasu to Skidegate Channel Eight kilometres (five miles) north of Tasu Sound is rocky Portland Bay where the overflow from a small lake creates a lovely falls as it tumbles some 30 metres (100 feet) into the sea. There is no shelter here during any wind or sea.

Kootenay Inlet has not been completely surveyed, but those willing to chance it will be rewarded by its beauty. The inlet is speckled with tree-covered islets, and there is a narrow but deep kilometre-long passage rimmed with overhanging trees that suddenly curves to reveal a large inner harbour. Low mountains surround the harbour and the game-filled valley at its head. The entrance holds a few bold black rocks where beds of thick kelp sway with the force of breaking waves. The deep and steep-sided north arm offers poor shelter.

In 1993 a logging road was constructed around the south and east sides of Kootenay Inlet, connecting with the road to Sewell. An interesting hike follows a dancing stream at the inlet's northeast portion, past a tumbled log cabin and through the ancient forest to other dilapidated cabins and the adit of an old gold mine.

At the head of narrow, nearly hidden Bottle Inlet, salt grass edges the timbered flats and a meandering stream spills into the salt chuck. In late summer the stream and adjacent portion of the inlet are alive with pink salmon that have come home to spawn, attracting bears and eagles eager to do their own brand of fishing.

Waters around Cape Henry and the entrance to Moore Channel move erratically over an irregular shoal bottom, creating – even in mid-channel – high waves and a short chop when ebb tide and westerly winds meet in conflict. East

of Englefield Bay, in Moore and Inskip channels, you have a chance to explore five inlets without venturing into the open sea. The first of these is Douglas Inlet, where chill fresh water may be obtained from a hose secured to a stiffleg and mooring buoy at the inlet's head – courtesy of the crew of the Department of Fisheries and Oceans patrol vessel, *Sooke Post*.

Mitchell Inlet (Gold Harbour) was the scene in 1851 of British Columbia's first gold rush. The gold was discovered by Haida living on the west coast; later it was mined by men of the Hudson's Bay Company, who began to worry when American ships arrived with prospectors from the California gold fields. HMS *Thetis* was ordered into the area to proclaim British sovereignty. Its crew was kept busy surveying and assigning place names. Soon the small lode was extracted and ever-hopeful prospectors rushed off to the Fraser River or Cariboo strikes. It is still interesting to wander around the old mine and get a few pictures of a small ore crusher rusting amid tumbled buildings.

On the shores of Thetis Anchorage, at the head of Mitchell Inlet, is the Charlottes' only hydroelectric plant. Water impounded in Moresby Lake rushes more than 300 metres (1,000 feet) through a drilled pass to spin three generators supplying electricity to Sandspit, Queen Charlotte, Skidegate and Tlell. This hydro project saves thousands of litres of diesel fuel annually.

A logging company operated in Peel Inlet from the mid-1960s to 1970, leaving a levelled camp area (now nearly overgrown with alder trees) and a rough hillside road used by bold drivers of four-wheel-drive vehicles, as well as hikers on their way to or from Moresby Camp on Cumshewa Inlet.

When heading seaward through Inskip Channel, toss a salmon lure over the side and slow to trolling speed, or stop and jig for halibut or lingcod. It shouldn't take long to catch the main course for your next meal.

World War II buffs might want to tramp through the spruce trees at Bone Point, the northwest extremity of Hibben Island, and search for the coast-watch cabin. Evidence of the coast watchers is easily found on the rocks and among the trees, but Betty and I haven't located remains of the cabin. Even one of the former watchers hovering over the point with us in a helicopter couldn't spot it.

The many islands and islets lying along the west face of Hibben Island provide opportunities for observing shorebirds, marine growth or lazy sea lions. We have counted 17 natural landslides on Hibben Island's west side. Narrow, wooded Luxmoore Island has a needle eye eroded through its southern side.

Instead of rolling all night in Kaisun Harbour or Boomchain Bay, anchor in Security Cove or in a bight along the south side of Security Inlet. Security Cove does not always live up to its name. During an early fall storm, the *Sooke Post* and our *Skylark* sought shelter here, and we both dragged anchor a few hundred metres (we both ended up dropping a second anchor). Set a crab trap anywhere on the cove's grassy, shallow bottom near a stream, or fish in the two fine salmon and trout streams meandering through magnificent stands of virgin timber before pouring into the cove. Deer often frolic along the shore, only to glide into the shadows of lichen-draped spruce trees as you approach in a skiff. The small cabin on the north side of the cove belongs to the federal Department of Fisheries and Oceans.

Tiny unsurveyed MacKenzie Cove has been the subject of hopeful study and test drilling by many prospecting crews, all of them intrigued by large deposits of limestone. To date, however, none have found anything of commercial value.

A single totem stands above the gravel shore of the abandoned Native village of Kaisun. Within the past two decades a landslide bulldozed through the centre of the old village. This rolling anchorage with scattered beds of kelp is guarded by islands, some with caves waiting to be explored. You might even sight a sea otter here, floating near a kelp bed while preening or feeding, as we once did. We have twice seen one of these animals along this coast.

Although Kitgoro Inlet has not been properly surveyed, it can be entered with caution (except at low tide) through a narrow, shallow and kelp-choked entrance. Betty and I have taken shelter here in deep water – anchored and tied to the trees – on the northwest side during a westerly storm exceeding 80 knots. The Haida once had a small camp here, and two stubby pilings are all that remain of a modest fish saltery. Just outside the entrance of the inlet and on the north side is a cave with old paintings and chiselled names and dates.

Just south of Buck Point is a tiny, shallow and rocky bay that may be entered with caution. Kayakers and those with lightweight inflatable boats can enjoy camping on the edge of the woods and alongside the shaded, pebbly stream.

Tide rips often occur off Buck Point's bold and worn rocks just south of the entrance to Buck Channel, especially if tide and wind are opposed. I usually avoid the worst of these troubled waters by rounding it near slack water and

staying close to the point. In summer trollers often work near the entrance to Buck Channel. Inside, on Chaatl Island's southwest side, is the old Native village of Chaatl where two totems remain to keep company with the spirits of ancient Haida. One pole wears three hats, a view often seen in Emily Carr's paintings. The better totem hides amid trees some 500 metres (1,640 feet) east of the village. Some people refer to one of its carved figures as a spider (to me, it is a mosquito). The venerable hereditary chief of Chaatl once told Betty what it was like to be a boy in that village when most of its inhabitants were dead or dying of smallpox: "I had no one to play with." What a poignant memory and succinct statement of tragedy.

At the head of Buck Channel is Chaatl Narrows (Canoe Pass), a 1.5-kilometre (one-mile), winding connection to Armentieres Channel where you can moor to buoys while waiting for better weather or higher tide. At low tide the narrows dries at the east end. It begins to cover when the tide tables predict 1.8 metres (six feet) of water at the reference port of Tofino. Those with small boats and local knowledge often use this pass. A well-maintained private cabin is located at the western end of the narrows. From Chaatl Island you can return through Skidegate Channel to the starting point of your Moresby cruise.

6 Gwaii Haanas National Park Reserve/Haida Heritage Site

In July 1987 the governments of British Columbia and Canada signed a memorandum of understanding leading to the creation of the Gwaii Haanas National Park Reserve/Haida Heritage Site. The actual park reserve agreement was finally signed in July 1988. Park officials opened an office in Queen Charlotte on Graham Island and commenced work to make the park an international tourist destination. In January 1993 the Gwaii Haanas Agreement was signed in Old Massett, setting out the terms of a unique arrangement for the administration and comanagement of the park reserve. The area will continue to be a park reserve until the active land claims of the Haida are settled. In the meantime, the Queen Charlottes will continue to go through a period of transition as adjustments are made to changing economic and social patterns on the islands.

In 1991 Parks Canada opened visitor information centres in Sandspit and Queen Charlotte. Staffed with knowledgeable people and filled with displays and photographs, these attractive centres are excellent places to commence and end a visit to the Charlottes. During the tourist season, a free, *mandatory* course is given daily at the information centres for those wishing to visit the park. At other times of the year arrangements to take this one-hour course may be made by phoning (250) 559-8818. Reservations are required for entering the

Two visitor information centres, one in the Sandspit air terminal and this one in Queen Charlotte, are excellent places to begin learning about the Charlottes.

park – advance reservations are suggested – and a fee will be charged commencing in 1998. No more than 12 people are allowed in one place at one time. The proposed marine park is in the planning process. If you intend to visit any of the old Haida villages in the Moresby Island region, you now need to register at a visitor information centre or at the Haida Gwaii Watchmen office in Skidegate.

The park is a wilderness area, accessible only by boat, floatplane or helicopter, and air entry has some restrictions. Additional mooring buoys are being set and the navigation aids upgraded. Search and rescue in this area is conducted by the Heritage Rescue and Conservation Warden. In summer you may see boaters and a passing plane or helicopter. If you are in need of assistance and see another person, craft or plane, use movement, reflection, silhouette or contrast to help you to be seen. Three of anything – fires, shots, flashes – are a standard distress signal. During summer months, Haida Gwaii Watchmen maintain base camps at the ancient villages of Skedans, Tanu, Ninstints and on Hotspring Island. You are on your own. If you think you *might* need something, bring it – within reason.

Tell a responsible person where you are going and when you expect to

return. A pocket-size VHF marine radio is a valuable piece of emergency equipment. Reception and transmission are poor in some areas, but you should be able to pick up the continuous weather reports. In an emergency, call the Prince Rupert Coast Guard on channel 16, the emergency channel, or use one of BC Tel's Marine VHF radio channels to telephone Search-and-Rescue Emergency at 1-800-742-1313 (no charge).

Survival suits or floater coats, distress flares and dye markers are as necessary to include in your gear as a sharp knife, waterproof matches and a pocket compass. One September Betty and I picked up a lone hiker on Moresby Island's rugged and lonely west coast. He was overdue because of unanticipated foul weather and topography tougher than his maps indicated. He attracted our attention with light from his camera's flash unit. "Have about 40 more flashes – I think," he told us. Wisely he left a time schedule with his girlfriend – she is now his wife – who got the search going.

Some 50 commercial operators offer land, sea or air services in the Gwaii Haanas National Park Reserve/Haida Heritage Site area from May through September; others, year-round. Services include guided tours, charter boats, kayak rental and passenger/equipment transportation. These boats and services vary in size, type and cost. Make all necessary reservations early. (For more information concerning the park reserve, consult the **Recreational Directory**.)

Random camping in the park reserve is encouraged. There are no established campsites or trails. Practise minimum-impact wilderness camping: respect water sources, locate your camp kitchen low in the intertidal zone, hang food bags out of reach of wildlife both large and small (and *never* in your tent), bury your sewage deeply and without trace and remove your litter. "Beaver fever" is an illness that has recently hit some locals and visitors. You may choose to boil your drinking water.

Information concerning the Gwaii Haanas National Park Reserve/Haida Heritage Site may be obtained at the Park Headquarters in Queen Charlotte, 120 – 2nd Avenue, tel. (250) 559-8818, or by writing Superintendent, Gwaii Haanas National Park Reserve/Haida Heritage Site, P.O. Box 37, Queen Charlotte, B.C., VOT 1S0.

For emergencies only, 24 hours, phone (250) 559-8484.

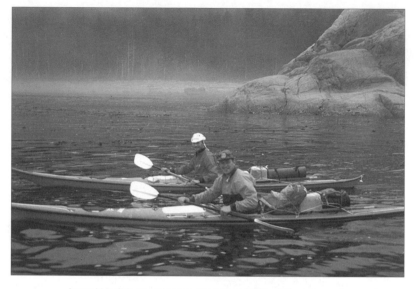

Intrepid kayakers challenge Moresby Island's wild west coast.

7 A Final Word

After reading this book, you may conclude that the seagoing aspects of the Queen Charlotte Islands have been overstressed. All islands are water-oriented; everyone and everything moving in or out of the Charlottes has to pass over or through the surrounding seas. For the Charlottes, the sea is the primary route for transportation, a place of employment, a source of food and an arena for recreation. The North Pacific's moderating influence on the Charlottes eliminates summer or winter extremes, thus making the islands' weather different from that of the mainland. Almost without exception all of the islands' settlements are alongside salt water.

No one should try to squeeze a visit to the Queen Charlottes into a rigid schedule. Flexibility is imperative for those travelling by sea; adequate time is often synonymous with safety. However you travel and whatever your budget, you will find the Charlottes a rewarding experience and a place to come back to.

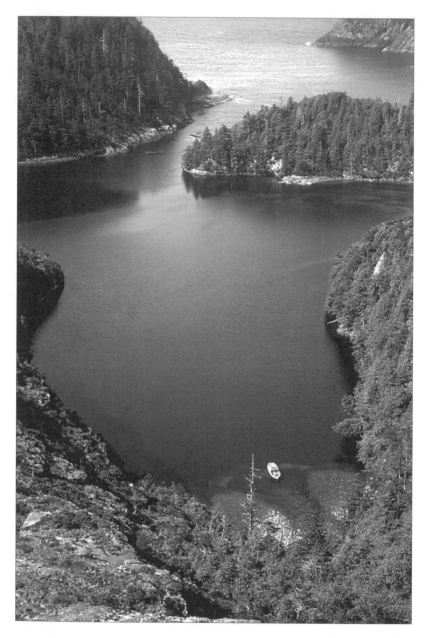

The entrance is narrow to spectacular Blue Heron Bay on Moresby Island.

Appendix 1: Weather

For those interested in checking the weather situation before deciding what type of clothing to pack for a trip to the Queen Charlotte Islands, here are a few figures based on observations taken over a period of 25 years at Sandspit and Masset.

Average temperature during coldest month, January	1.7° C (35° F)
Average daily maximum during January	4.2° C (40° F)
Average temperature during warmest month, August	14.5° C (58° F)
Average daily maximum during August	17.8° C (64° F)
Average annual temperature	7.8° C (46° F)
Maximum recorded temperature	28.9° C (84° F)
Minimum recorded temperature	-18.9° C (-2° F)
Average precipitation during wettest month, October	201 mm (7.9")
Average precipitation during driest months, May-August	58 mm (2.3")
Total average precipitation annually	1,356 mm (53.4")
Maximum recorded rainfall in one day	80 mm (3.1")
Number of days a year with precipitation	213
Number of days a year with snowfall	18
Number of days a month with fog	2

Appendix 2: Maritime Mobile Service Channels

Station Frequencies

Purpose	Ship	Coast	VHF Channels
Distress, Urgency, Safety and Calling	156.8 MHZ 2182 kHz 500 kHz	156.8 MHZ 2182 kHz 500 kHz	16
Continuous Weather Weather, Traffic List and Notships	 2054 kHz	*161.65 *162.55 *162.40 **2054 kHz	21B WX1 WX2
Ship and Coast Guard Public Correspondence	157.3 157.225 2054 kHz 2340 kHz	161.9 161.825 2054 kHz 2458 kHz	26 84

 * continuous broadcast
 ** broadcast at scheduled times

Appendix 3: Useful Information

Clothing Dress in the islands is generally informal. The same outdoor wear you would pack for an excursion to Vancouver Island, the Inside Passage, Puget Sound, coastal Oregon or northern California is appropriate. Something in lightweight or medium-weight wool, a waterproof lightweight jacket (brightly coloured for pictures) and comfortable waterproof walking or hiking shoes will all come in handy.

Film Most stores carry a variety of 35 mm colour-print film. Film for colour transparencies (slides) and Polaroid cameras is not always stocked. A few stores carry VHS videocassettes. Plan on doubling your usual amount of shooting, whether you specialize in people, nature, landscapes, seascapes, rainbows, sunrises or sunsets. Videotape for camcorders is available in some communities. One-hour colour-print film processing is available in Skidegate.

The Metric System For the convenience of American visitors who may not be familiar with the metric system, most of the measurements in this guide are given in both metric units and their Imperial system equivalents. Weights and measures have usually been rounded to the nearest whole number. Visitors can easily convert kilometres to miles by multiplying the number of kilometres by .62 or simply .6. To convert temperatures from Celsius to Fahrenheit, multiply the degrees Celsius by nine, divide by five and add 32. Gasoline is sold by the litre: 3.785 litres equals one U.S. gallon.

Customs and Immigration Visitors from the United States may be asked to document their citizenship with a birth, baptismal or voter's certificate. Passports are required for visitors from other countries. Naturalized American citizens should carry their naturalization certificates. Permanent American residents who are not citizens should have their alien Registration Receipt Cards with them. Revolvers, pistols and fully automatic firearms are prohibited. Dogs and cats from the United States, if more than three months old, must be accompanied by a certificate signed by a licensed veterinarian of Canada or the U.S., certifying that the animal has been vaccinated against rabies during the preceding 36 months.

Currency/Credit Cards Use of Canadian funds in cash or traveller's cheques is recommended. Banks and credit unions offer the prevailing rate of exchange. Many businesses do not give a full rate of exchange. Major credit cards are usually welcome.

Camping Camping along one of the Charlottes' many fishing streams or on a secluded beach is a pleasant and inexpensive way to explore the islands. Nearly all streams have trout and, depending upon the time of year, may have salmon or steelhead. With a rod and reel your meal is often no farther away than the nearest stream. Although the islands have only a few organized campgrounds, there are miles of accessible public beaches and camping or overnight parking is usually permitted in the inactive parts of tree farms. A drive or hike along almost any unused logging road will bring you to an enticing camping spot. Do you prefer your views to be gentle or rugged? Streams, mountains, forest or sea – you can choose a campsite with any one of these views or a combination of them. Open campfires are a hazard in the woods. Save your fire for the beach – but not amid the drift logs. The British Columbia Ministry of Forests requires that a shovel and a nine-litre (two-gallon) container of water be on hand for extinguishing campfires. (See the **Recreational Directory** for a list of parks and campgrounds.)

Beachcombing Hiking any of the Charlottes' many and diverse beaches is excellent exercise and a rewarding experience for the photographer, beachcomber or individual merely wishing to take home wonderful memories of these magnificent islands. The variety of treasures washed ashore are nearly

limitless. What one person overlooks may be just what someone else is seeing. Many of Graham Island's beaches offer agates, usually cream-coloured, as well as large iridescent weathervane scallop or delicate razor clamshells. These are not found on the shores of Moresby Island. Fishing floats are frequently found on most of the Charlottes' beaches. Plastic floats from baseball- to medicine-ball size and of varied colours are most often seen. The much sought after Japanese glass fishing floats are less frequently discovered by the casual beachcomber. After a half century of picking them up, it still makes my day if I find one – large or small. Driftwood, polished by sand and waves, is also collected by many people. Sometimes you might find a dead whale which, depending on whether it is ripe or the bones are bleached by sun and rain, may or may not be a pleasant experience. Occasionally a storm-wracked ship will lose some of its deck cargo, usually one or more of its containers. When that happens, the contents can be scattered by wind, currents and tides for hundreds, even thousands of kilometres. In May 1990 80,000 Nike shoes were lost during a storm; they washed up on beaches from Alaska to California and were a good find for anyone lucky enough to get a matched pair. One of my friends picked up a pair and presented them as a Mother's Day gift. Betty and I have come across oars and paddles just when we needed them. More recently a dozen 12-metre (40-foot) containers were lost on the other side of the international date line. Each contained about 29,000 plastic bathtub toys, some of which were found on Alaskan beaches. These losses have provided oceanographers with a lot of information about currents and drift patterns, enabling them, in 1996, to accurately predict when and where thousands of pieces of lost hockey equipment would be cast ashore.

Whale Watching One of the most memorable experiences in the Queen Charlottes is the first sighting of a whale. You should have a pretty good chance to spot grey whales, either from the ferry taking you to the Charlottes or while hiking the shoreline. The whales migrate up the North American West Coast from Baja to Alaska in the spring, which means you will likely sight them from late April to June. Good places to watch are from the ferry *Kwuna,* near the Queen Charlotte Islands Museum in Skidegate, anywhere along the beach at Skidegate and at Rose Spit, northeast of Masset. Make sure you have a pair of binoculars and a telephoto lens on your camera.

Birdwatching The Queen Charlottes are a feast for birdwatchers. Millions of birds visit or nest on the Charlottes, and although the number of species are not as great as found in mainland British Columbia, there are enough unusual ones to keep any birdwatcher happy. Peregrine falcons, bald eagles, dark-eyed juncos, black-footed albatrosses, all four members of the loon family, sandhill cranes, murrelets, auklets, puffins, hairy woodpeckers, saw-whet owls and cormorants are just a few of the birds you might see here. Rose Spit on Graham Island is a great spot to sight both shore and seabirds, including auklets, peregrine falcons, terns, sandhill cranes and shearwaters. At Sandspit, Kagan Bay and the ferry docks in Skidegate Inlet you will have a good chance to spot resident shorebirds as well as a good number of migratory birds. Delkatla Wildlife Sanctuary near Masset should not be missed. Here you will find sea, beach and forest birds, including sandhill cranes, sandpipers, bald eagles, dowitchers, killdeers and cattle egrets. The Yakoun River estuary near Port Clements is also a good birdwatching site. To view seabird colonies you will need a boat. Islands such as Anthony, Kerouard, Rankine, Lyell, Louise, Burnaby, Hippa and Langara are all excellent locations to view nesting seabirds, including storm petrels, cormorants, glaucous-winged gulls, murrelets and puffins. Some islands require a special permit to land at any time (see the For More Information section of the **Recreational Directory** for where to inquire about permits). Seabird colonies are fragile, so be very careful when viewing them. Try not to disturb the colonies in any way. Consult a good birdwatching field guide about appropriate birding etiquette. You will also find a pair of binoculars and a telephoto lens for your camera necessary equipment to increase your enjoyment of the Charlottes' varied bird life.

Bears As of late 1997 no one has been injured by a bear in the Charlottes, but I am hearing of encounters with local black bears who have less than the normal fear of humans. Bears can move fast, are unpredictable and have the claws, teeth and strength to do great harm to people, pets and your boat or camp equipment. Given the time to think, they will usually move away, but not always. *Beware, be careful and stay alert.* During our years in the North I have had two serious confrontations with black bears. While I was on the mainland as a winter watchman at an isolated logging camp, a bear broke into the cookhouse storeroom. While I was cleaning up the mess, the bear and I met at the

doorway – less than 1.5 metres (five feet) from nose to nose. The second time was during a stay at Puffin Cove one October, when what we believe was a dwarf black bear – not a cub – wanted to move in with us. We were unafraid of each other. The bear lay on the cabin floor and slept while I napped. Before leaving I used a broom to encourage him to get out. A sudden swipe to the broom with a sharp-clawed paw showed me that we were unequally matched. When outside and the door was closed, the bear clawed at and slapped the windows, then chewed at the pane dividers in an effort to get in.

Emergency Telephone Numbers

Royal Canadian Mounted Police: Masset (250) 626-3991; Queen Charlotte (250) 559-4421.

Queen Charlotte Islands General Hospital: Queen Charlotte (250) 559-4300; Emergency (250) 559-4506; Pharmacy (250) 559-4310; Medical Clinic Physicians (250) 559-4447.

Queen Charlotte Islands Health Care Society: Clinic, Masset (250) 626-3918; Clinic, Port Clements (250) 557-4478; Clinic, Sandspit (250) 637-5403.

Tourist Alert Because of emergencies at home, the Royal Canadian Mounted Police are often asked to locate people on vacation. There are Tourist Alert bulletin boards at many provincial campgrounds and Travel Information Centres, as well as radio messages.

Attractions

Haida Gwaii Museum This museum is an attractive wooden structure overlooking Second Beach at the western edge of Skidegate Reserve on Graham Island. Here you will find Haida totems and argillite carvings, settlers' relics, natural history exhibits and photographs of Haida and pioneers, all attractively displayed. In this centrally located museum residents learn about the past, while tourists may begin an acquaintance with these out-of-the-way islands. The gift shop stocks books and modern Haida art. Nearby are two cedar-and-plastic sheds utilized by carvers working on cedar totem poles. You might be fortunate enough to photograph one or more of the artists at work.

Ed Jones Haida Museum Located on a knoll near the north side of Old Massett, this museum overlooks the community recreation field and a few recently carved totems. Inside, numerous Haida artifacts are attractively displayed, including many from archaeological digs at Kiusta and Lucy Island.

Port Clements Museum Opened in 1987, this is the newest of the Queen Charlottes' museums. It is located on the waterfront side of Port Clements' through road. More items are added to the museum yearly. The most recent acquisition, a donkey engine and steam drill used to test for coal in the Yakoun Valley, was hauled out of the bush where it had been abandoned in 1912. The museum houses numerous local logging, mining and fishing displays, as well as household items used by early settlers. Objects and photographs are well identified. A large covered shed contains many pieces of old equipment. The heavy equipment is displayed near the large parking area. The museum is open on Thursday, Saturday and Sunday afternoons.

Family Trout Derby Late in May the Sandspit Rod and Gun Club sponsors a Family Trout Derby at Mosquito Lake (open to all), adjacent to the road between Sandspit and Moresby Camp. Public camping spots and picnic tables along the shoreline are claimed early by those wishing to be in the middle of the action while enjoying a view of verdant hillsides and snowcapped mountains. Some people camp or park RVs in nearby Moresby Camp. Free hot dogs, pop and coffee are available for all. Trophies and prizes are awarded in a variety of categories to lucky anglers of all ages. No admission charge.

Coho Salmon Derby The last two weekends in September and first two in October have a special attraction for fishermen of all ages. This is the Sandspit Rod and Gun Club's annual Coho Salmon Derby. Resident and visiting entrants try for the big coho (silver salmon) of the Charlottes, competing for an array of prizes and trophies awarded in four categories. A small entry fee is required. Trophies and valuable prizes are awarded for (1) the largest coho caught by anyone with an entry ticket, (2) the largest coho caught by an entrant under age 14, (3) the coho caught by the youngest contestant and (4) the largest coho caught by a female ticket holder. For a person to be eligible for the prizes, the coho must be taken in the area between the Deena River and

the south point of Gray Bay during any Saturday or Sunday of the derby weekends. To win one of the big prizes, an angler will likely have to catch a coho in excess of 7.3 kilograms (16 pounds). In 1991 I won second place with a 7.4-kilogram (16.3-pound) coho. Usually the winner must land a salmon weighing more than eight kilograms (18 pounds). One year the prize-winning coho weighed in at more than 10.8 kilograms (24 pounds). There are free boat launching sites at Copper Bay, Sandspit, Alliford Bay and at the head of Cumshewa Inlet.

Singaay Laa (Skidegate Days) Annually this celebration attracts an ever-increasing number of visitors and locals. It begins on a Friday evening in early June with a feast, bingo, softball games and canoe races. Saturday is a busy day with more races, tug-of-war, assorted booths and a barbecue dinner, then ending with a dance at the large recreation hall. This is a fine way to see and photograph Haida regalia, as well as sample a variety of delicious Haida foods while enjoying water and shore sports competitions.

Community Day The Charlottes' final fair of the summer is held in Queen Charlotte on the first weekend after Labour Day. It opens Saturday forenoon with the first game of a two-day slow-pitch ball tournament and a parade. A soap box derby, dunk tank, golfing and chipping contests, a kids' beach walk, music, plus a variety of foods fill the afternoon. Prizes are awarded in a number of categories. In the evening a delicious dinner is the prelude to a $15,000 raffle draw – plus appropriate second and third prizes. An always-popular dance completes Saturday's events. The ball tournament continues on Sunday with assorted food concessions and other attractions.

Hospital Day Annually this celebration is held in Queen Charlotte on a Saturday after mid-June. It includes a colourful parade, numerous races afloat and ashore, softball games, waterskiing, helicopter rides, arts and crafts displays and sales, concessions and, of course, lunch and dinner to sustain visitors through this day-long event, which concludes with a dance. This festival originated more than 75 years ago as a fundraiser for the islands' general hospital. Each year this event raises money for a special project.

Contestant Dave Dixon demonstrates his expertise during Sandspit's Logger Sports Day.

Logger Sports Day On a Saturday in mid-June loggers from throughout the Queen Charlotte Islands, the mainland and Vancouver Island gather in Sandspit to compete in a number of industry-related events. The day's activities start with a parade of decorated vehicles, bicycles and pets. The logger who accumulates the largest score wins the handsome King Logger Trophy. It is a day of excitement when these able-bodied men come out of the bush to demonstrate the many skills required in their trade. Cameras click as husky men in plaid shirts take part in the fast-action birling contest. Two agile men leap onto a floating log, their caulked boots digging like claws as each man – using his weight and catlike sense of balance – tries to spin the log, first in one

direction and then, after a fast stop, in the other direction, until one man is caught off balance and splashes into the chill water. For the pole climb, contestants strap sharp spurred irons onto their legs, cinch thick leather safety belts around their waists, adjust their climbing ropes and race, squirrel-like, up a 24-metre (80-foot) pole to ring a bell mounted at the top. Seventy seconds is a good time for this exhausting event for the high-riggers. For safety, men are timed only on the climb, not the round trip, so they no longer plummet to the ground. Next, their axes honed to razorlike sharpness, loggers await the signal to start swinging in the horizontal- and standing-chop events. Axes bite deep with a musical ring and wedge-shaped chips fly. In a matter of seconds the winner has made a smooth cut through an alder log. Cleverly customized chain saws are tested once more as the beginning of the bucking contest nears. Snarling saws come to life with powerful roars, blades drop onto logs and golden sawdust jets forth as meticulously filed chains slash through logs. It is over in seconds. Saws silent, the judges inspect the blocks to see if the cuts are straight. Other events include choker setting (connecting a heavy wire rope around a log that is lying on the ground), obstacle bucking (running up an angled log while holding a power saw, starting the saw, cutting off a length and returning to the ground), crosscut sawing, wire splicing and a tug-of-war. One of the most spectacular events is the axe throw, in which short-handled axes are hurled at a bull's-eye painted on the butt of a large log. And there are events for ladies, too: birling, choker setting, peavey logrolling, bowline tying, crosscut sawing and nail driving. To the winner of the women's events goes the Queen Logger Trophy. Boys compete in a choker-setting contest. Refreshments are available throughout the day, as are various games of skill for visitors of all ages. No admission charge.

Canada Day On the long July 1 weekend Port Clements hosts a full program of events for all ages. Activities start Friday evening with local artists performing their own music, comedy and poetry in a coffee house. Saturday begins with a big breakfast followed by a parade of decorated vehicles, bicycles and pets. At the community park there are ball and dart tournaments, floor hockey, raffles, games of skill and a great variety of foods. Features and events are added each year. This enthusiastic celebration ends with a well-attended Saturday evening dance. No admission charge.

The Willows Golf Course This popular nine-hole course in Sandspit is part of a pioneer homestead along the shores of Hecate Strait. It is open year-round, weather permitting, which in the mild climate of the Charlottes might mean golfers could work off that overstuffed feeling that follows a Christmas or New Year's dinner. During the long summer days, players can often be seen enjoying the course until after 10:30 p.m. Sand traps, natural water hazards, groves of trees and fairways totalling 2,700 metres (3,000 yards) result in a course with a par 36 for men and par 39 for women. The course has 18 tees and provides enjoyment for good golfers and a workout for duffers. Refreshments and food are available at the clubhouse, where carts and clubs may be rented and balls and tees replaced. Each August the Willows Open, a mixed tournament, attracts contestants from the western provinces and the Pacific Northwest.

Dixon Entrance Golf and Country Club This lovely golf course lies in the rhythmically rolling dunes between the blue waters of Dixon Entrance and the road from Masset to Tow Hill. A number of challenging 18-hole tournaments are conducted each year in this handsome and unusual setting. The final tournament is usually in October.

Fall Fair This popular fair is held in August at the Tlell fairgrounds, across the road from the Naikoon Provincial Park headquarters. Inspect the exhibits of livestock, vegetables, flowers, home preserves and crafts while listening to musical entertainers. Artwork and food is sold from numerous booths. Neither rain nor wind deters islanders and tourists from flocking to this enjoyable event. Admission is $5. Gate prizes include helicopter, plane and boat trips, as well as accommodations.

Appendix 4: Recreational Directory

The following is a list of services most likely to be of interest to visitors to the Queen Charlotte Islands. Details regarding schedules, fares, accommodations, et cetera are those available in late 1997, are subject to change and are offered only as guides. It is recommended that visitors contact the businesses concerned for rates and reservations.

The telephone area code for Vancouver, B.C., and the rest of the Lower Mainland, Fraser Valley, Sunshine Coast and Whistler/Howe Sound regions is 604. The area code for the rest of British Columbia, including Vancouver Island and the Charlottes, is 250.

Postal codes for addresses in the Queen Charlotte Islands are: Juskatla V0T 1J0; Masset V0T 1M0; Port Clements V0T 1R0; Queen Charlotte V0T 1S0; Sandspit V0T 1T0; Sewell V0T 1V0; Skidegate V0T 1S1; and Tlell V0T 1Y0.

Goods and Services Tax (GST): Nonresidents of Canada may apply for a rebate of the seven percent GST. Obtain a copy of GST *Rebate for Visitors* from Revenue Canada Customs and Excise when you enter Canada, and remember to save all of those receipts.

For 24-hour highway reports, telephone 1-900-451-4997 at a charge of 75 cents per minute.

Air Schedules

Canadian Regional Airlines: Reservations and information: 1-800-665-1177.

Vancouver to Sandspit and return daily. Morning and afternoon flights most days of the week. Reduced fares for seniors and when reservations are made in advance.

Harbour Air Ltd.: Reservations and information: (250) 559-0052. Fax: (250) 559-0054. Daily flights from Prince Rupert to Queen Charlotte/Sandspit (Alliford Bay) and return. Two flights daily from Prince Rupert to Masset and return. Masset: (250) 626-3225; Prince Rupert: (250) 627-1341. Also charter flights. Head office, Vancouver: 1-800-663-4267.

Air Charters

South Moresby Air Charters Ltd.: P.O. Box 969, 3102 3rd Ave., Queen Charlotte, (250) 559-4222. Cessna 185 on floats.

Vancouver Island Helicopters Ltd.: Box 333, Sandspit (Sandspit Airport), (250) 637-5344. Bell Jet Ranger and Hughes 500, 4 passengers. Helicopter charters cost about $800 per hour of flight time and offer about one to one and a half hours on the ground for each hour of flight time. This makes helicopter charter competitive with boat charter when one considers the speed of flying and the more direct course between point of departure and destination. Discuss the dates you will be on the islands and proposed itinerary with a helicopter pilot. If the weather at your destination is not favourable, enjoy local sightseeing or fishing. When the skies clear, your experienced pilot will notify you, and you and your party can enjoy a comfortable flight and an exciting adventure.

Ferries

From June 1 through mid-October the 101-metre (332-foot) *Queen of Prince Rupert* makes four to six trips weekly between the Charlottes and Prince Rupert, and the 125-metre (410-foot) *Queen of the North* plies between Prince Rupert and Port Hardy, Vancouver Island, departing these ports on alternate mornings for a memorable 15-hour daytime cruise of the magnificent Inside Passage. From mid-October until May 30 the *Queen of Prince Rupert* or the *Queen of the North* runs between Prince Rupert and Skidegate three times a

week, and once a week between Prince Rupert and Port Hardy. Passengers who have a permanent disability and require an attendant may travel at reduced rates. Call for information.

Reservations are strongly recommended. For reservations anywhere in British Columbia, phone 1-888-BCFERRY (223-3779); in Victoria, B.C., (250) 386-3431. Fax (250) 381-5452 (Victoria). When within the Charlottes: Queen Charlotte terminal, (250) 559-4485. Or write: British Columbia Ferry Corporation, 1112 Fort St., Victoria, B.C., v8v 4v2.

Ferry service between Moresby and Graham islands is provided by the 72-metre (235-foot) MV *Kwuna*; capacity is 25 cars and 150 passengers. Frequent crossings daily. First trip departs Alliford Bay, Moresby Island, at 7:00 a.m. and the last leaves Skidegate, Graham Island, at 10:30 p.m. Save by purchasing books of vehicle and passenger tickets at the booth in Skidegate. British Columbia seniors (passengers only) travel free Monday through Thursday, except statutory holidays.

Boat Charters and Water Taxis (Operators residing in the Charlottes)

Commercial operators whose names are underlined are licensed to operate in Gwaii Haanas National Park Reserve/Haida Heritage Site. Services are not necessarily endorsed, and the list may change.

Anvil Cove Charters: Sixteen-metre (53-foot) schooner. Adventure tours, kayaking, natural and cultural history. Box 454, Queen Charlotte, (250) 559-8207 or 559-8990 or 1-800-668-4288.

Archipelago Ventures: Wilderness voyages. Box 999, Queen Charlotte, 1-888-559-8317.

Avocet Lady: Sixteen-metre (53-foot) schooner. Charters and adventure tours. Box 81, Queen Charlotte, radiophone N112112 on channel 64 Louise Island.

Cartwright Sound Charters: Fishing, sightseeing, whale watching. Box 87, Sandspit, (250) 637-2277.

Frank's Fishing Charters: Two-unit cabin with kitchen and smokehouse. Box 155, Sandspit, (250) 637-5423 (tel./fax).

Gwaii Haanas Tours and Diving Adventures: Box 409, Sandspit, (250) 637-5666.

Harvest Charters: River and ocean charters, cabins. Box 458, Masset, (250) 626-5152.

Husband Charters: Box 733, Queen Charlotte, (250) 559-4582.

Kingfisher Charters: Box 313, Sandspit, (250) 637-5497.

Kwuna Point Charters: Box 184, Sandspit, (250) 559-8966.

Laurich Charters: Fishing and tours. Box 436, Sandspit, (250) 637-2200.

McIntyre Bay Tours: Fishing and tours. Box 499, Masset, (250) 626-3431 or 626-3622.

Moresby Explorers Ltd.: Zodiac tours, kayak rentals, wilderness adventures. Box 109, Sandspit, (250) 637-2215 or 1-800-806-7633.

Naden Lodge: Box 648, Masset, (250) 626-3322 or 1-800-771-8933.

New Wave Charters: Fishing and tours. Box 206, Masset, (250) 626-3210.

North Isle Marine: Box 22, Masset, (250) 626-5010.

Northwest Marine Adventures: Box 135, Sandspit, (250) 637-5440.

Ocean Spray: Fishing and whale watching. Box 206, Sandspit, (250) 637-5698.

Old Tyme Charters: Fishing and accommodations. Box 86, Masset, (250) 626-5042.

Pacific Silver Fishing Charters: Box 320, Masset, (250) 626-3242.

Paradise North Fishing Charters: Up to six people, day charters only. Box 394, Queen Charlotte, (250) 559-8901.

Queen Charlotte Adventures: Anthropological and natural history tours. Box 196, Queen Charlotte, (250) 559-8990 or 1-800-668-4288.

Rose Harbour Guest House: Licensed for charter boat only. Box 437, Queen Charlotte, radiophone N159057 on channel 24 Cape St. James.

SMC: Charters and water taxi. Box 174, Queen Charlotte, (250) 559-8383 or radiophone N115934 on channel 64 Louise Island. Channel 06 VHF.

Starlock Charters: Box 1212, Skidegate, (250) 559-4760.

Boat Charters (Operators residing off-island)

Bluewater Adventures: (Sail) #3-252 East 1st St., North Vancouver, B.C., V7L 1B3, (604) 980-3800.

Charbonneau Charters: Box 502, Prince Rupert, B.C., V8J 3P6, (250) 627-1132.

Clavella Adventures: Box 866, Nanaimo, B.C., V9R 5N2, (250) 753-3751.

Duen Sailing Adventures: (Sail) 364 East 24th St., North Vancouver, B.C., V7N 3Y2, (604) 987-7635.

Ecosummer Expeditions: (Sail) 1516 Duranleau St., Vancouver, B.C., V6H 3S4, (604) 669-7741 or 1-800-465-8884.

Maple Leaf Adventures: (Sail) 3055 Cassier Ave., Abbotsford, B.C., v2s 7G9, (604) 240-2420.

Ocean Visions: (Sail) 4449 West 10th Ave., Vancouver, B.C., v6R 2H8, (604) 228-0248.

Rupert Pelican Tours: (Sail) Box 532, Prince Rupert, B.C., v8J 3R5, (250) 627-0817.

Sail Secord: (Sail) Box 181, Bowen Island, B.C. von 1G0, (250) 947-2413.

Takuli III Sailing Charters: (Sail) 539 Mountainview Ave., Colwood, B.C., v9B 2B2, (604) 685-6107.

Taxi and Bus Service

Bruce's Taxi: Sandspit, (250) 637-5655.

Eagle Cab QCI Ltd.: Meets all Canadian Regional Airline flights at Sandspit, (250) 559-4461.

Jerry's Taxi Service: Old Massett, (250) 626-5017.

Pete's Taxi and Charter Bus Tours: Skidegate, (250) 559-8622.

Vern's Taxi: Masset, (250) 626-3535.

Car Rentals

Budget Rent-A-Car: Sandspit Airport, Masset or Queen Charlotte, (250) 637-5688 or 1-800-577-3228.

Rustic Car Rentals: Queen Charlotte, (250) 559-4641.

Thrifty Car Rental: Sandspit Airport, (250) 637-2299.

Tilden Rent-A-Car: Masset, (250) 626-3318.

Twin Services: Queen Charlotte, (250) 559-8700.

Note: During the busy summer and fall seasons, it is advisable to phone or write for confirmed reservations. Service stations are located in Masset, Port Clements, Queen Charlotte, Sandspit and Skidegate. Seat belt use is mandatory in British Columbia for drivers and all passengers. Drinking and driving is a crime in British Columbia and the province is waging an aggressive war against impaired drivers. The risk of being caught is great; for even a first offence, penalties are serious.

Mooring Buoys

Armentieres Channel, head	Louscoone Inlet, east side
Beal Cove	Marchand Reef
Beattie Anchorage	Mazarredo Islands
Bruin Bay	Murchison Island, north side
Carew Bay	Naden Harbour, George Point
Carmichael Passage	Nesto Inlet
Cox Island	Peril Bay
Dawson Harbour	Pillar Bay
Douglas Inlet	Powrivco Bay
Givenchy Anchorage	Ramsay Island, north side
Goose Cove, Port Chanal	Rose Harbour
Gordon Cove	Section Cove
Henslung Cove	Skedans
Hotspring Island	Skidegate Narrow, east end
Hoya Passage	Tanu Island
Jedway Bay	Tartu Inlet
Kiokathli Inlet	Thurston Harbour
Kiusta	Windy Bay
Louise Narrows	

Hotels/Motels

(Rates vary from $30 to $90 per person)

MASSET
Harbourview Lodging: Box 153, 1608 Delkatla St., (250) 626-5109 or 1-800-661-3314. 5 units. $40 and up.
Singing Surf Inn: Box 245, 1504 Old Beach Rd., (250) 626-3318. 30 units. Restaurant and lounge, boat charters, vehicle rentals, small gift shop. $74 and up.

PORT CLEMENTS
Golden Spruce Motel: Box 296, 2 Grouse St., (250) 557-4325. 12 units. $42 and up.

QUEEN CHARLOTTE
Dorothy & Mike's Guest House: Box 595, 3125 2nd Ave., (250) 559-8439. 5 units.

Full kitchen facilities. $35 and up.

Gracie's Place: Box 447, 3113 3rd Ave., (250) 559-4262. 4 units. Some kitchenettes. $50 and up.

Hecate Inn: Box 124, 321 3rd Ave., (250) 559-4543 or 1-800-665-3350. 16 units. Kitchenettes. $55 and up.

Premier Creek Lodging: Box 268, 3101 3rd Ave., (250) 559-8415 or 1-888-322-3388. Fax (250) 559-8198. 12 units. Some kitchenettes. $30 and up.

Sea Raven Motel and Restaurant: Box 519, 3301 3rd Ave., (250) 559-4423 or 1-800-665-9606. Fax (250) 559-8617. 29 units. Some kitchenettes. $45 and up.

Spruce Point Lodging: Box 735, 609 6th Ave., (250) 559-8234. 7 units. $55 and up.

ROSE HARBOUR

Gwaii Haanas Guest House: Box 578-P, Rose Harbour, Queen Charlotte. March-October, (250) 624-8707; October-March, (250) 559-8638. 3 units. Accommodation and meals. Kayak rentals. $95.

SANDSPIT

Moresby Island Guest House: Box 485, 385 Beach Rd., (250) 637-5300. 10 units. Laundry. $30 and up.

Sandspit Inn: Box 469, Airport Rd., (250) 637-5334. Fax (250) 637-5334. 35 units. Some kitchenettes, lounge and dining room, gift shop. $64 and up.

Seaport Guest House: Box 206, 371 Beach Rd., (250) 637-5698. Fax (250) 637-5697. 10 units. Boat tours and fishing charters. $30 and up.

TLELL

Tlell River House: Box 56, Beitush Rd., (250) 557-4211. Fax (250) 557-4622. 10 units. Dining room, lounge, boats and fishing tours. $70 and up.

Weavers Inn Motel: Box 12, Highway 16, (250) 557-4491. 4 units. $50 and up.

Fishing and Hunting

Information listed here is intended as a guide only. Obtain current regulations from businesses selling hunting and fishing licences, or by writing: Ministry of Environment, Wildlife Branch, P.O. Box 9374, Stn. Provincial Govt., 29/5

Jutland Rd., Victoria, B.C., v8w 9M4.

Fishing Licence Requirements: Everyone 16 years of age and over wishing to fish in the tidal and nontidal waters for finfish (all fish other than shellfish or crustaceans) is required to have in their possession a valid fishing licence. A steelhead licence is required in addition to the angling licence when fishing for steelhead. A classified waters licence is also required – if guided or a nonresident of British Columbia – between September 1 and March 31 for fishing the following streams in the Queen Charlottes: Copper, Datlamen, Deena, Honna, Mamin, Pallant, Tlell and Yakoun.

When hunting big game, nonresident hunters must be accompanied by a licensed British Columbia guide. A licence to carry firearms and to hunt all game is required, and there are big-game tag fees.

Licensed Guides

Walter Ernst: Guide-Outfitter, Copper Bay Lodge, Box 52, Sandspit, B.C.
Udo Weigel: Queen Charlotte Guide-Outfitter, Box 5, Site 12, RR #1, Spruce Grove, Alberta, T7X 2T4, (403) 963-0142.
Note: Reservations several months in advance are recommended; rates available upon request.

Shops and Services

Art Galleries: Masset, Queen Charlotte, Sandspit, Tlell.
Automobile Garages and/or **Service Stations:** Masset, Port Clements, Queen Charlotte, Sandspit, Skidegate.
Beauty Salons: Masset, Port Clements, Queen Charlotte, Sandspit.
Bowling: Masset, Queen Charlotte.
Campgrounds: Agate Beach Campground, near Tow Hill in Naikoon Provincial Park, open year-round, overnight user fee May through September, 21 sites; Misty Meadows Campground, south end of Naikoon Provincial Park near Tlell, open year-round, overnight user fee May through September, 30 sites; Rennell Sound Wilderness Campsites, maintained by the B.C. Ministry of

Forests, several campsites, largest has seven sites; Kagan Bay Campsite, near Queen Charlotte, maintained by the B.C. Ministry of Forests, four sites; Gray Bay Campsite, near Sandspit, several wilderness sites, with two more sites at nearby Sheldens Bay; Mosquito Lake Campground, near Moresby Camp, 12 sites. For more information on campsites maintained by the B.C. Ministry of Forests, call (250) 559-6200 and ask for the recreation coordinator.

Ceramics: Queen Charlotte, Sandspit, Tlell.

Churches: Old Massett, Masset, Port Clements, Queen Charlotte, Sandspit, Skidegate.

Cleaners and Laundry: Masset, Queen Charlotte, Skidegate.

Clothing Stores: Masset, Queen Charlotte, Sandspit, Skidegate, Tlell.

Credit Unions: Masset, Queen Charlotte.

Dentists: Masset, Queen Charlotte.

Doctors (physicians and surgeons): Masset, Queen Charlotte.

Golf: Dixon Entrance Golf and Country Club, Masset; The Willows Golf Course, Sandspit.

Government Agent: Queen Charlotte, (250) 559-4452.

Grocery Stores: Masset, Port Clements, Queen Charlotte, Sandspit, Skidegate, Tlell.

Haida Artwork: Old Massett, Masset, Queen Charlotte, Sandspit, Skidegate. Note: Inquire at Old Massett or Skidegate about artists currently carving argillite or wood, working with gold, silver, or copper, weaving hats or baskets or silk-screening. The list of local Haida artists is constantly changing and expanding. A wide variety of styles and prices also exist.

Haida Band Councils: Old Massett Band, (250) 626-3337; Skidegate Band, (250) 559-4496.

Hospitals: Queen Charlotte, (250) 559-4300. (Public Health Nurse, Masset, [250] 626-3918.)

Jewellery Shops: Old Massett, Masset, Queen Charlotte, Sandspit, Skidegate, Tlell.

Kennels: Richardson Kennels, Tlell, (250) 557-4276.

Liquor Stores (closed Sundays and holidays): Masset, Queen Charlotte, Sandspit.

Marine Charts: Sandspit Information Centre; Meegan's Store, Queen Charlotte.

Marine Fuels: Skidegate (year-round); Masset (fuel barge in summer).

Marine Repairs: Port Clements, Queen Charlotte, Sandspit.

Newspaper: *Queen Charlotte Islands Observer,* Box 205, Queen Charlotte, (250) 559-4680.

Notaries Public: Masset, Queen Charlotte, Sandspit.

Parks: Gwaii Haanas National Park Reserve/Haida Heritage Site (includes Anthony Island), Headquarters, Box 37, 120-2nd Ave., Queen Charlotte, (250) 559-8818; Naikoon Provincial Park (includes Tlell and Tow Hill provincial parks), Headquarters, Box 19, Highway 16, Tlell, (250) 557-4390; Queen Charlotte Visitor Information Centre, (250) 559-8316; Sandspit Visitor Information Centre, (250) 637-5362.

Pharmacies: General Hospital, Queen Charlotte, (250) 559-4310; Health Care Society, Masset, (250) 626-3918.

Photo Services: Queen Charlotte, Skidegate (one-hour processing).

Post Offices: Juskatla, Masset, Port Clements, Queen Charlotte, Sandspit, Sewell, Tlell.

Propane: Masset, Port Clements, Queen Charlotte, Sandspit.

Radio: Although there are no commercial radio stations in the Charlottes, there are AM and FM repeater stations. Daytime reception is normally good, picking up Prince Rupert, Ketchikan, Vancouver and Victoria. Evening reception is especially good; inexpensive radios bring in stations from as far east as Calgary and as far south as Los Angeles and Salt Lake City.

Restaurants (not affiliated with a hotel or motel): Masset, Port Clements, Queen Charlotte, Sandspit.

Royal Canadian Mounted Police: Masset, (250) 626-3991; Queen Charlotte and Sandspit, (250) 559-4421.

RV Sites: Masset, Port Clements, Queen Charlotte, Sandspit.

Television: The Charlottes receive a number of TV channels via satellite and offer cable service to most communities.

Travel Agencies: Masset Travel, Masset, (250) 626-3604 or 1-888-275-8888; Rikka Travel, Queen Charlotte, (250) 559-4400 or 1-800-899-4399.

Variety and Gift Shops: Old Massett, Masset, Port Clements, Queen Charlotte, Sandspit, Skidegate, Tlell.

Veterinarian: Tlell, (250) 557-4468.

For More Information

Travel in British Columbia: Write to the Ministry of Tourism, Parliament Buildings, Victoria, B.C., v8v 1x4, or phone 1-800-663-6000. Many communities have information centres; these are good places to obtain local information, provincial road and park maps and the excellent *British Columbia Accommodations 199-* (updated annually), which lists most hotel/motel accommodations by community. Prices, facilities, number of units, addresses and phone numbers are included in this free publication that is organized by highway route. Another useful and free publication is the annually updated *British Columbia Bed & Breakfast Directory*, available at information centres or tourist information offices.

For disabled people planning a trip in British Columbia, write or phone: Canadian Paraplegic Association, 780 S.W. Marine Dr., Vancouver, B.C., v6p 5Y7, (604) 324-3611.

Ferry Information and Reservations: B.C. Ferry Corporation, 1112 Fort St., Victoria, B.C., v8v 4v2, (250) 386-3431. Fax (250) 381-5452. Anywhere in B.C., 1-888-BCFERRY (223-3779). For Alaska Ferry information, write or phone: Alaska Marine Highway System, Box R, Juneau, Alaska, 99811, (907) 465-3941 or 1-800-642-0066. Contact Washington State Ferries at 2499 Ocean Ave., Sidney, B.C., v8L 1T3, (250) 656-1531. Or, 801 Alaskan Way, Seattle, wa, 98104, (206) 464-6400.

Related Reading

Brown, A. Sutherland. Geology of the Queen Charlotte Islands, B.C. *Victoria: Department of Mines and Petroleum Resources, bulletin 54, 1968.*

Campbell, R. Wayne, et al. The Birds of British Columbia. *2 vols. Victoria: Royal British Columbia Museum, 1989.*

Carey, Neil G. Puffin Cove. *Vancouver: Hancock House, 1982.*

Carr, Emily. Klee Wyck. *c. 1941. Toronto: Clarke, Irwin, 1971.*

Chittenden, Newton H. Exploration of the Queen Charlotte Islands. *1884. Vancouver: G. Soules, 1984.*

Collison, William H. In the Wake of the War Canoe. *Victoria: Sono Nis Press, 1981.*

Dalzell, Kathleen E. The Queen Charlotte Islands. *2 vols. Queen Charlotte City,* 1968 (1774-1966); *1973* (Of Places and Names).

Duff, Wilson, and Michael Kew. "Anthony Island: A Home of the Haidas." Report of the Provincial Museum. *Victoria: Royal British Columbia Museum, 1957.*

Gill, Ian. Haida Gwaii: Journeys Through the Queen Charlotte Islands. *Vancouver: Raincoast Books, 1997.*

Harris, Christie. Raven's Cry. *Toronto: McClelland and Stewart, 1966.*

Horwood, Dennis, and Tom Parkin. Islands for Discovery. *Victoria: Orca Book Publishers, 1989.*

Islands Protection Society. Islands at the Edge: Preserving the Queen Charlotte Islands Wilderness. *Vancouver: Douglas and McIntyre, 1984.*

MacDonald, George F. Ninstints: Haida World Heritage Site. *Vancouver: University of British Columbia Press, 1983.*

Poole, Francis. Queen Charlotte Islands: A Narrative of Discovery and Adventure in the North Pacific. *1872. Vancouver: Douglas and McIntyre, 1972.*

Smyly, John, and Carolyn Smyly. Those Born at Koona. *Vancouver: Hancock House, 1973.*

Stewart, Hilary. Cedar. *Vancouver: Douglas and McIntyre, 1984.*

Index

Page numbers in parentheses indicate maps
Page numbers in italics indicate photographs

Haida Gwaii
Journeys Through the Queen Charlotte Islands
Ian Gill
Photography by David Nunuk

Find out why the Queen Charlotte Islands have fascinated and enchanted people for thousands of years. Comprised of three different, very personal journeys, *Haida Gwaii* captures much of the potency of a unique place and people, largely thanks to author Ian Gill's wry observations and poetic insight and David Nunuk's breathtaking colour photography. It's all here: the past and present exploits of the remarkable Haida people; the coming of European colonizers; the environmental ravages and latter-day campaigns to reverse the damage already done; the quiet dignity and eloquence of the Ninstints totem poles; and the wild beauty of Gwaii Haanas, "the Place of Wonder."

150 pages, over 60 photographs (colour & black-and-white), softbound, $24.95 CDN, $18.95 US, ISBN 1-55192-068-9